# I Am Because We Are

## African wisdom in image and proverb

**Betty Press**

Proverbs Compiled by Annetta Miller
Foreword by Joanne Veal Gabbin
Introduction by Christiana Chinwe Okechukwu
Afterword by Alison Nordström

*In the spirit of ubuntu*

*Betty Press*

First edition of
I Am Because We Are:  African Wisdom in Image and Proverb

Published in partnership with
Books For Africa whose goal is to end the book famine in Africa.

Books For Africa
253 East 4th Street • Suite 200 •
St. Paul, MN, USA 55101
www.booksforafrica.org

www.bettypress.com
www.africanwisdominimageandproverb.com

Book design by Paul Tynes
www.paultynes.com

Printed by Oceanic Graphic Printing in China.

First edition 2011

ISBN: 978-0-9835454-4-6

Dedicated to the people of Africa who have taught us so much wisdom through their proverbs.

Life is a proverb of creation.
African proverb

# Contents

The title of the book comes from a well-known proverb *I am because we are; we are because I am* attributed to South Africa. It speaks to the interconnectedness and responsibility that we have for each other. It embodies the concept of *Ubuntu*, the African idea of living harmoniously in community.

Foreword by Joanne Veal Gabbin

Introduction by Christiana Chinwe Okechukwu

The black and white photographs of unique moments in African daily life are combined with related proverbs to illustrate traditional African wisdom. Together they tell the story of life, moving through:

family, home, education, relationships, work, leisure, environment, conflict, peace, music, dance, religion, wisdom, old age, death.

Finally, they come full circle with hope, as life goes on with the descendants and the living community.

Afterword by Alison Nordström

About Books For Africa

About the Authors and Contributors

Index of Photographs

Acknowledgments

# Foreword

*I Am Because We Are: African Wisdom in Image and Proverb* is a stunning collection of photographs taken by Betty Press while she lived and traveled in Africa. One hundred and twenty-five photographs have been paired with African proverbs compiled by Annetta Miller, an American born in Tanzania and living in East Africa most of her life. In proverbs, philosophy and poetry have a fine marriage. Such is the relationship between Press' black and white photographs and the proverbs that root these images in our collective mind and spirit. Though these images are of people living on another continent, speaking many different languages, living in different countries, and following diverse cultural rituals, we see them through the lens of the profound humanity that they represent. Betty Press allows us to be more than voyeurs. She takes us behind the eyes of a Peul girl who sees her beauty reflected in a small mirror; she takes us into the mind of a Sudanese boy whose ritual face paint cannot conceal his misgivings about his initiation into manhood. Her photographs fix in our minds communities that are vibrant and complex, filled with the drama of life that will bring tragedy and misery as quickly as joy.

I was immediately drawn to this book because of these striking photographs and the poetry that I found in abundance on these pages. A wise one said, *Proverbs are the palm oil with which words are eaten.* Proverbs, like poems, are concise, loaded with metaphors, wisdom, nuance, and the rhythms of life. In this volume language is best

digested with proverbs. When I read one of the proverbs in this collection: *Better a piece of bread with a happy heart than wealth with grief,* I recalled that my mother would often say, "Better to have a morsel of bread in peace than a banquet in confusion." I realized that the philosophical foundations that I stand upon were delivered in these cogent bits of advice throughout my upbringing. "When it rains, it pours" was my father's explanation for troubles that seemed to trip over each other in bringing us misfortune. On the eve of my wedding, my mother, who was demure, especially when speaking of sexual relationships, gave me this cryptic piece of advice: "Always keep something covered or you will become as a sister to him." With each passing year, I review her words and marvel at the wisdom she packed into them, words that have served me well for more than forty years of marriage.

Toi Derricotte writes in one of her poems, "poems do that sometimes—take /the craziness and salvage some/small clear part of the soul." Proverbs have in their very nature the idea that the collective conscience of the community is weighed in every line. Perhaps that is why this book has such an attraction for me because the photographs capture time as images and the proverbs take me home to a place that nourishes the soul. Take for example the cover photograph which shows the genius of the photographer's technique. As we survey three Senegalese women, their radiant shoulders and glinting gold jewelry that decorates their ears, our gaze is drawn to the woman with penetrating and kind eyes. The batik designs that drape their bodies and adorn their heads add a beauty that almost competes with the cherubfaced child in the background. This photograph hints at the chaos that frames these women and salvages radiance, mystery, happiness, and hope for the future in the essence of its message.

In this collection, the message is significant and life-affirming: *I am because we are; we are because I am.* We exist in community with a multiplicity of voices, and we thrive because we share the responsibility for that community with others. When Annetta Miller heard the Kenyan proverb: *Treat the earth well; it was not given to you by your parents, but was loaned to you by your children,* she must have wondered about the mind who created it. In it is the wisdom of griots who have traced the lineage of their people, told the stories of their ancestors, and passed them on to their children. The power of this collection is that we are able to see the engaging images of the heirs of this wisdom and hear the voices of continuity, identity, and legacy that affirm their communal spirit.

Joanne Veal Gabbin
Executive Director of the Furious Flower Poetry Center
Professor of English at James Madison University, Harrisonburg, Virginia

# Introduction

Proverbs are "the palm oil with which words are eaten" (Chinua Achebe's *Things Fall Apart*); they are aphorisms that capsulate a people's explanation of the origin of the universe. They deal with views on life and existence, being, friendship, values, love, human relations, death, concepts of time: temporality and historicity. More importantly, they are pungent rhetorical weapons used to include and exclude in many cultures. Thus Igbo people have a proverb that says, a *tuolu omalu omalu, mana a tuolo ofeke, ofelu isi tinye na-ofia*. This means when you use a proverb to talk to the wise, the wise will understand fully, but when you use a proverb to talk to the *ofeke* (the worthless individual) it will be lost on the person.

The proverbs in this volume, selected by life-long resident of Africa Annetta Miller, succinctly capture the concepts of age, existence, friendship, honesty, knowledge, life and existence, punctuality, respect, temporality, the cyclical nature of time, existence as a continuum, intrusion into space, the fragility of the earth/environment, the configuration of spatiality in relation to society as a unit, the individual vs. the society, value for human beings above wealth, etc. These proverbs carry the burden of the philosophy of the group from which they emanate. Miller has the African society being dealt with by taking cognizance of the pithy nature of the proverbs to avoid being confounded in an attempt to comprehend the people whose worldview is embodied in these proverbs. Africa is rich in these proverbs.

African, as well as non-African, scholars have written immensely in their bid to interpret Africa to the world. Betty Press is one more interpreter, even though from outside Africa; therefore she views with an outsider's gaze. Using photography to interpret the proverbs has also added another dimension to the efforts at interpreting this great oratorical art of the African people. Africa is a great harvest in which many are accommodated just as at the Mbari court of the Igbo people. Betty Press has paved her own path and contributed to the pot. Others will definitely follow. That is the how it should be, for in the great chief's courtyard, there are always contributions from all segments of the family. Betty Press' work will serve as one more avenue for giving accessibility to the meanings of the proverbs and the comprehension of the great people of Africa.

Lack of such appreciation had impeded the West's comprehension of Africa while the West was grappling with the whole concept of the African. The colonizers saw a simplistic, illogical, childlike people and spent years trying to fathom why these people could not be pigeon-holed, given their nature as the colonizers saw them. No European should presume to know about Africa, nor should any African presume to know the Western world, unless that person is taught from within the culture and has mastered the inner speech embodied by the culture's proverbs. Press and Miller's book has started the journey in the right direction. It does not pretend to know all. It seeks answers. That is how it should be. The title captures the essence of the African person. It embodies the concept of inter-relationships which even though it recognizes the individuality of a person, places the person within the body of the society which gave birth to the person—a relationship that promotes an interdependence that serves as an enabler and not a constrictor. A poignant Zimbabwean proverb in the collection buttresses this worldview: *If you want to walk fast, walk alone; if you want to walk far, walk with others.*

Christiana Chinwe Okechukwu
Professor, Department of Reading, English as a Second Language and Linguistics, Montgomery College, Rockville, Maryland

Proverbs are short sentences edited from long experiences.
North African proverb

All who live  under the sun are plaited together like one big mat.
African proverb

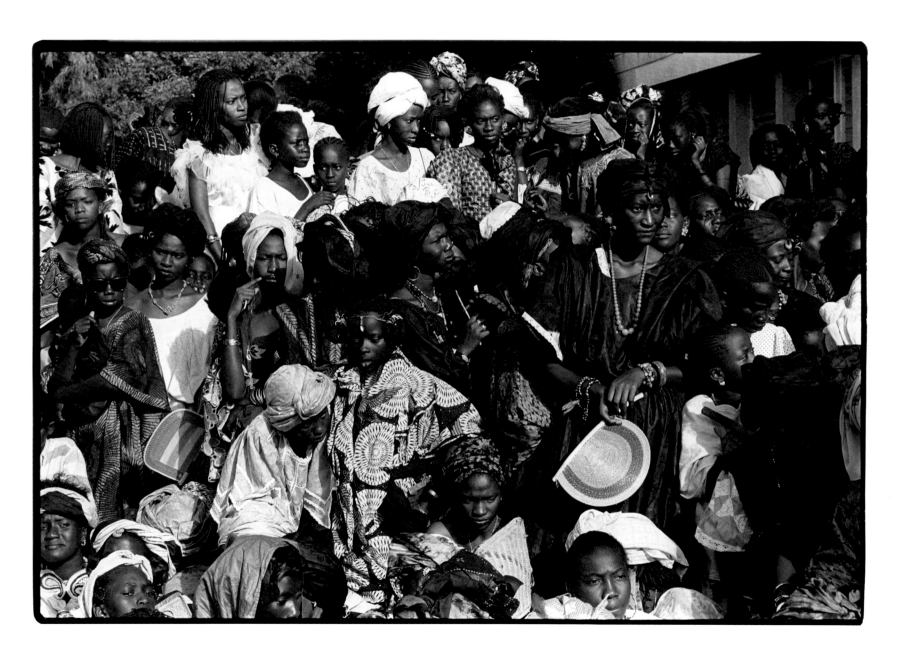

Life is in community.
African proverb

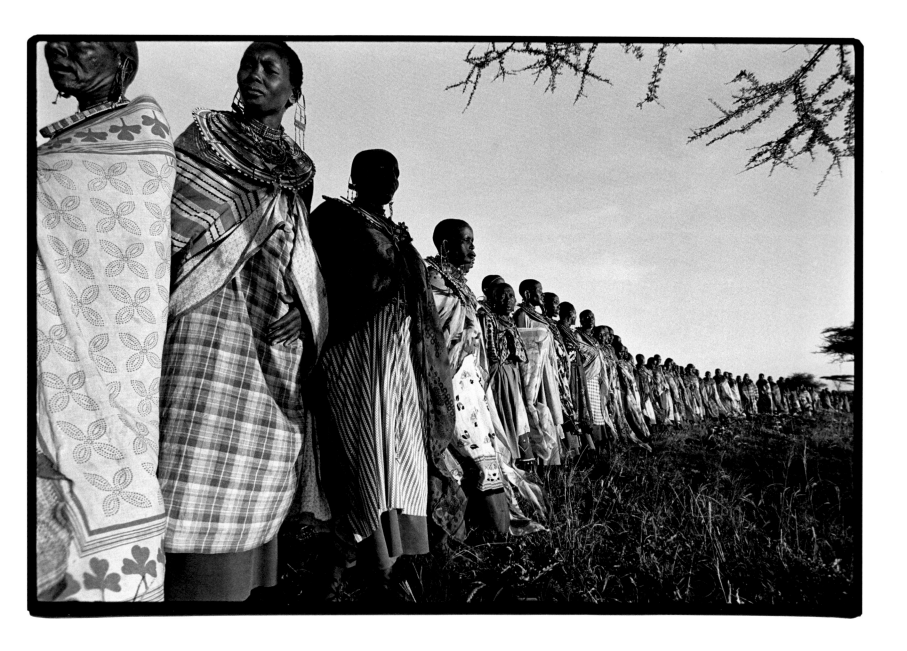

Life is the best gift; the rest is extra.
Tanzanian proverb

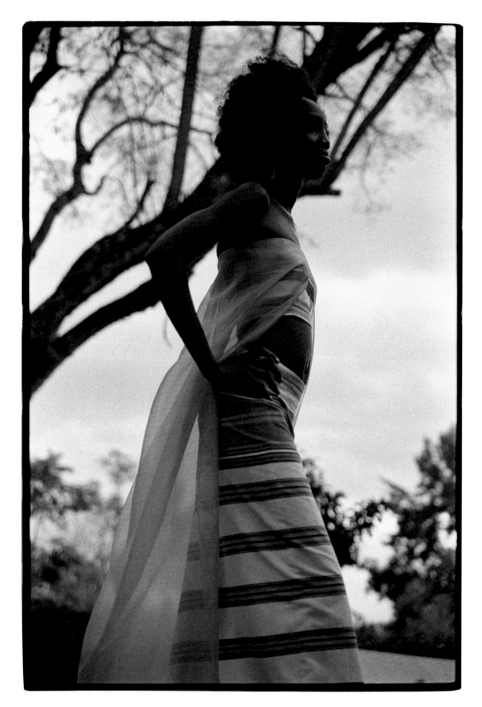

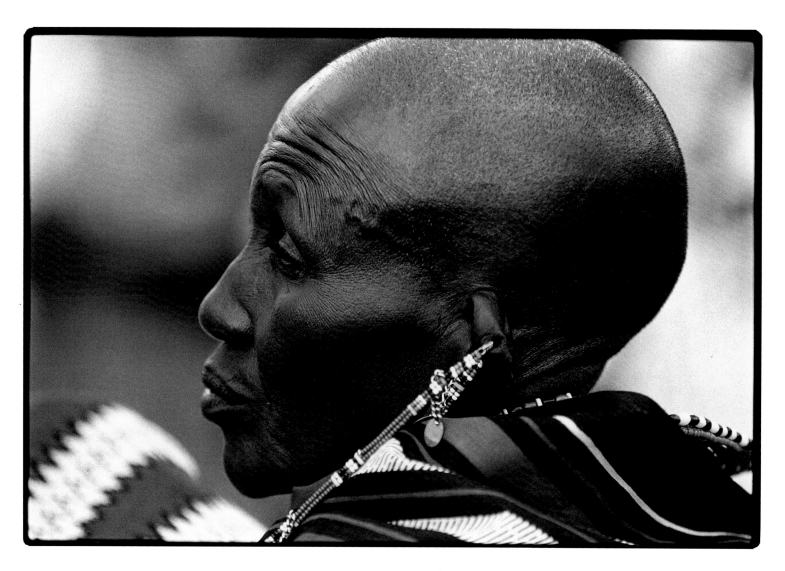

Life is a gift of nature but beautiful living is a gift of wisdom.
Malawian proverb

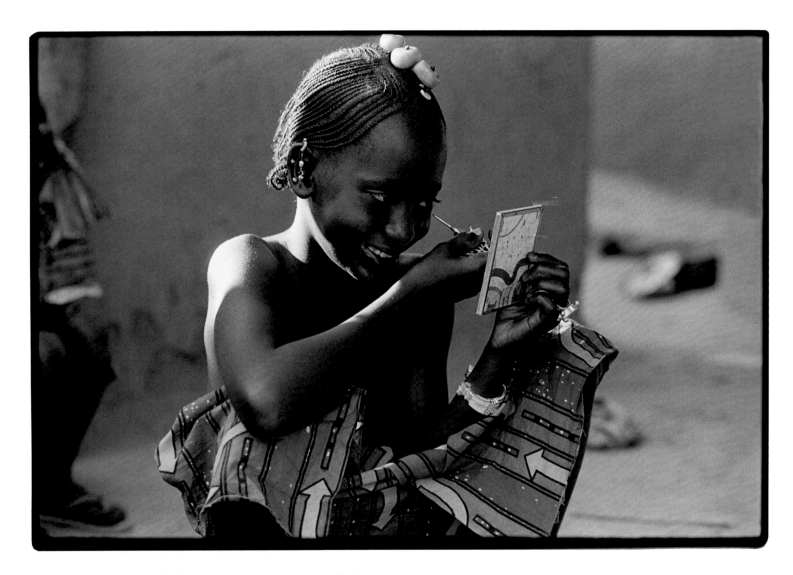

The world is a mirror; it looks at you the same way you look at it.
North African proverb

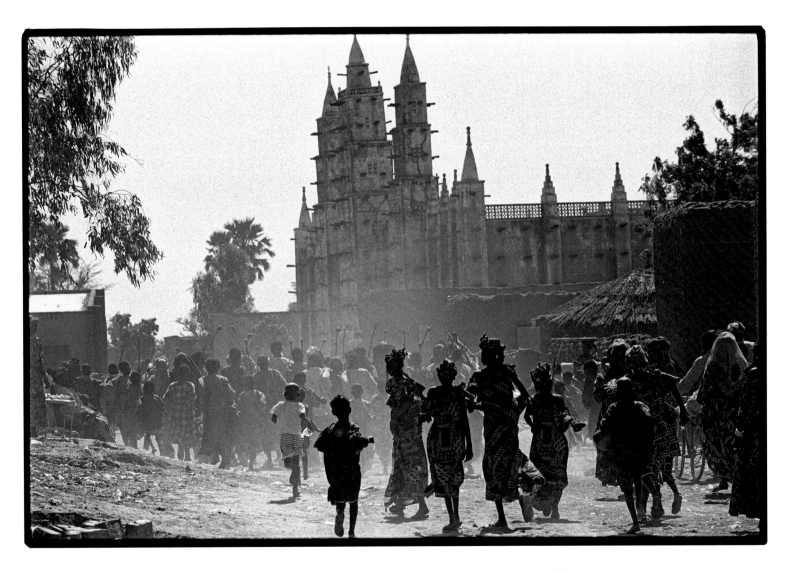

Life is lived forwards but understood backwards.
Congolese proverb

Every day of your life is a page in your history.
North African proverb

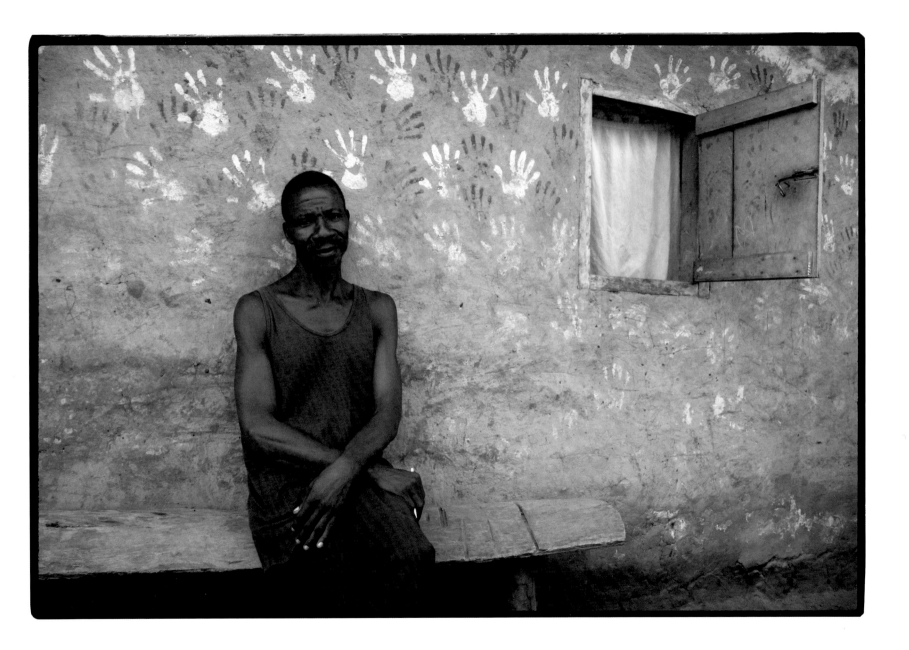

In the great river of life there are large and small fish.
Ghanaian proverb

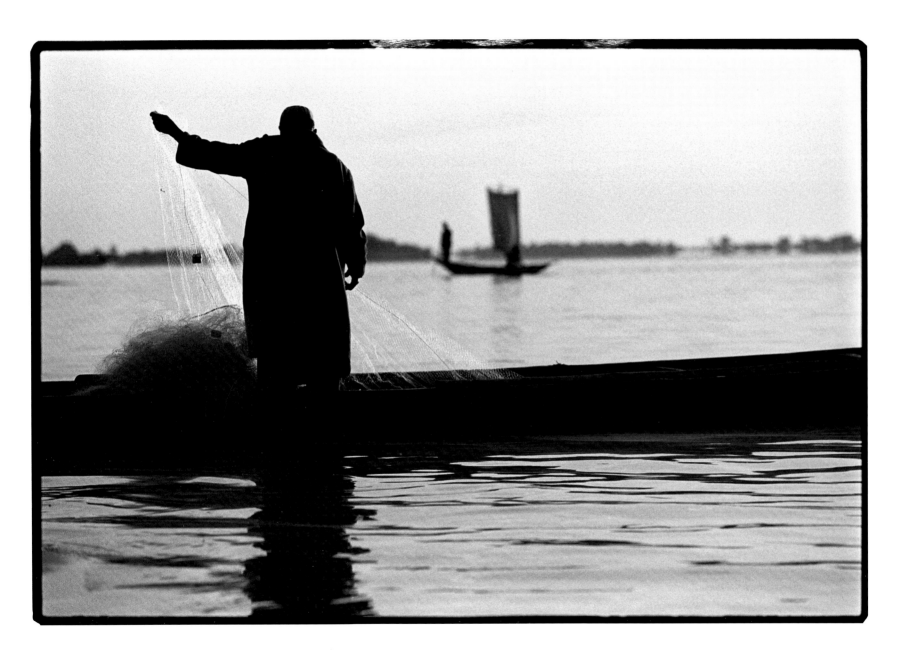

Each day that goes by and
I am all right is a feast.
North African proverb

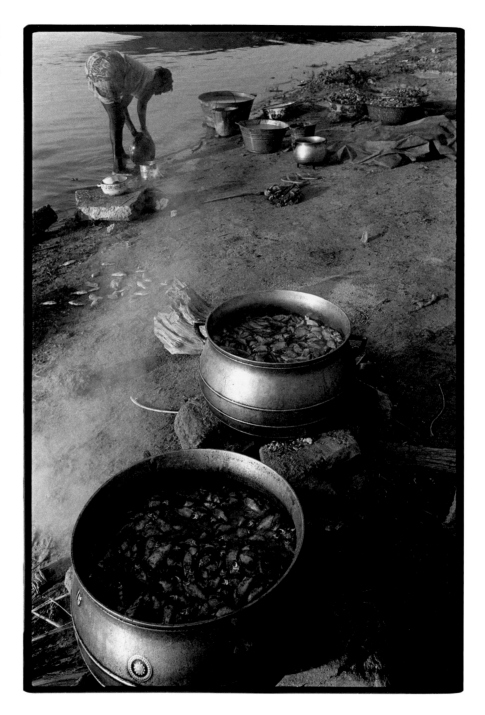

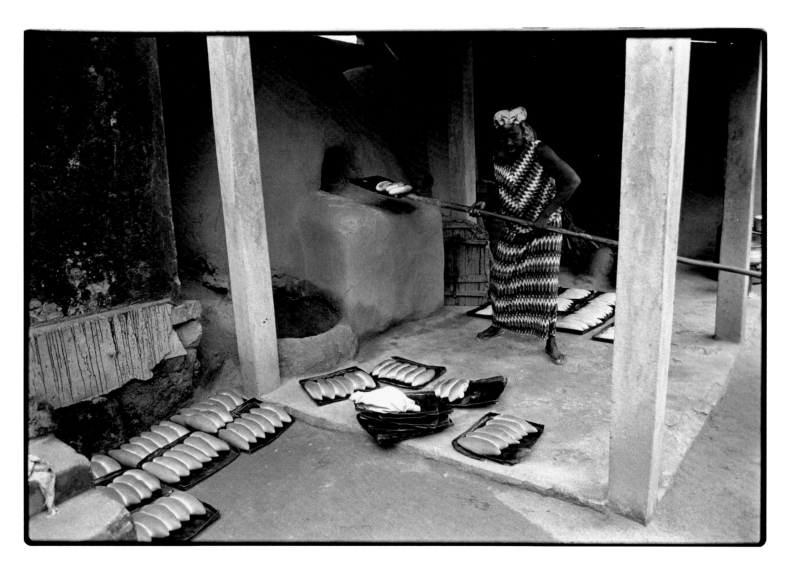

Better a piece of bread with a happy heart than wealth with grief.
North African proverb

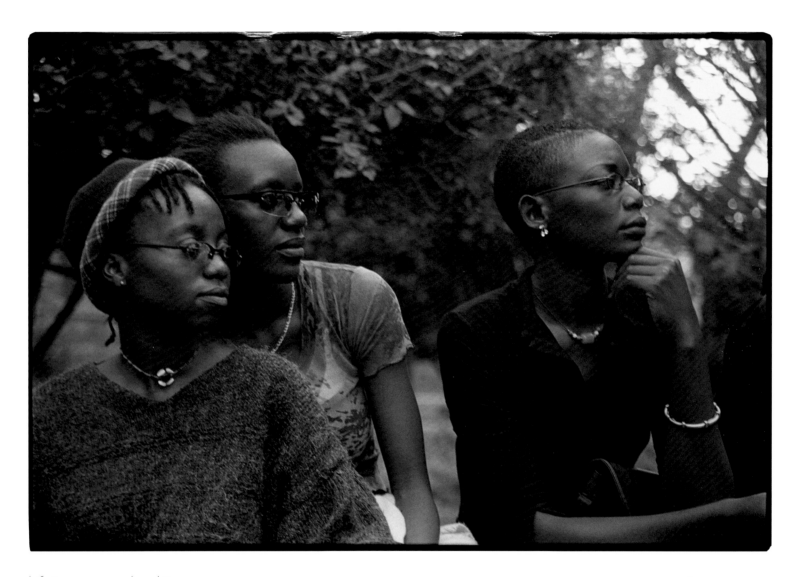

Life is a message; heed it.
South African proverb

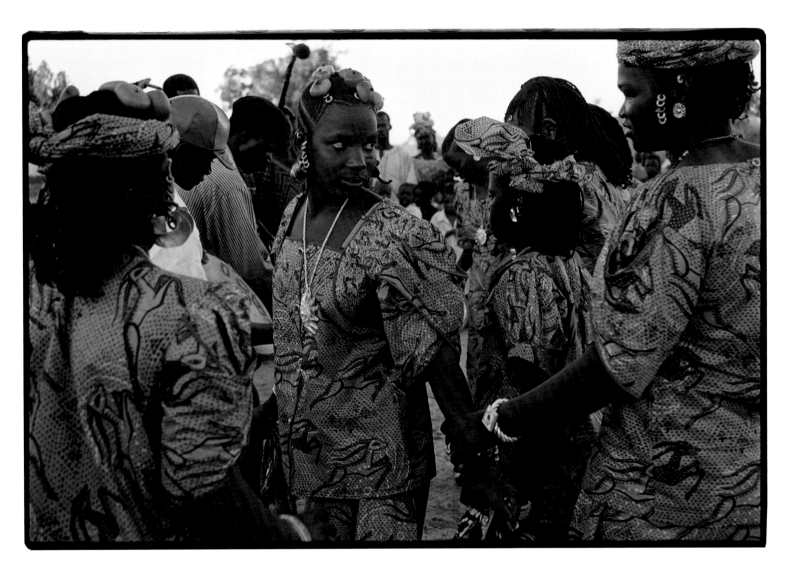

Some secrets of life can never be deciphered.
African proverb

Life is best lived at a walking pace and best understood at a sprint.
Zambian proverb

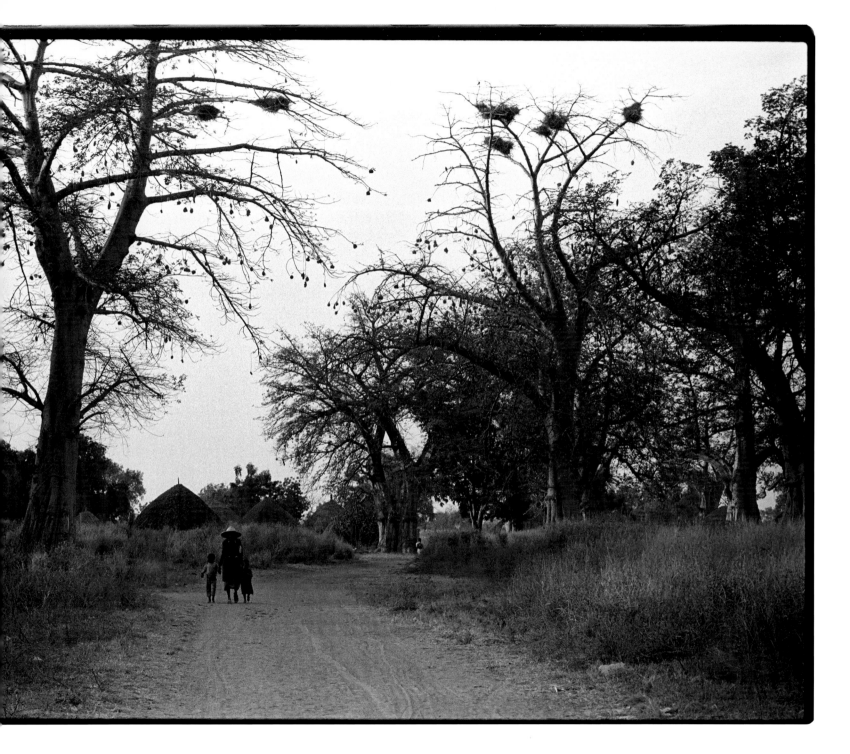

Life cannot be hurried.
Kenyan proverb

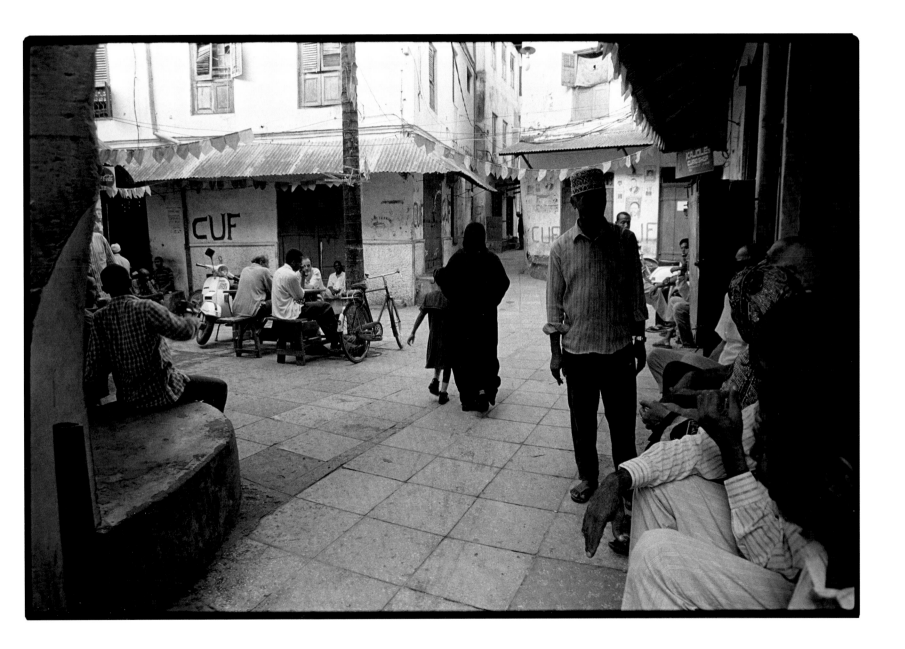

The lives of animals are parables of our lives.
African proverb

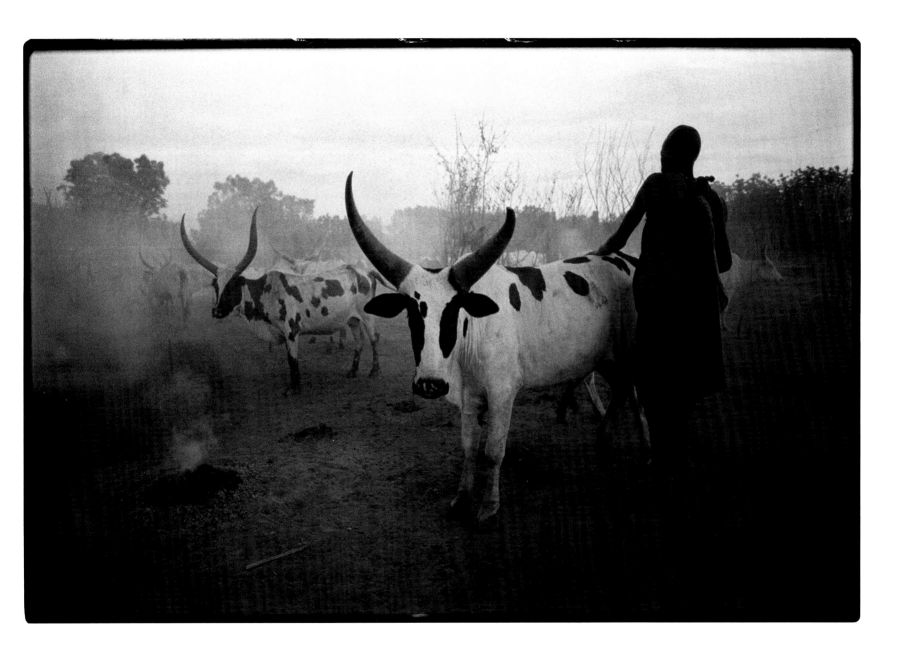

The world is zigzag.
Kenyan proverb

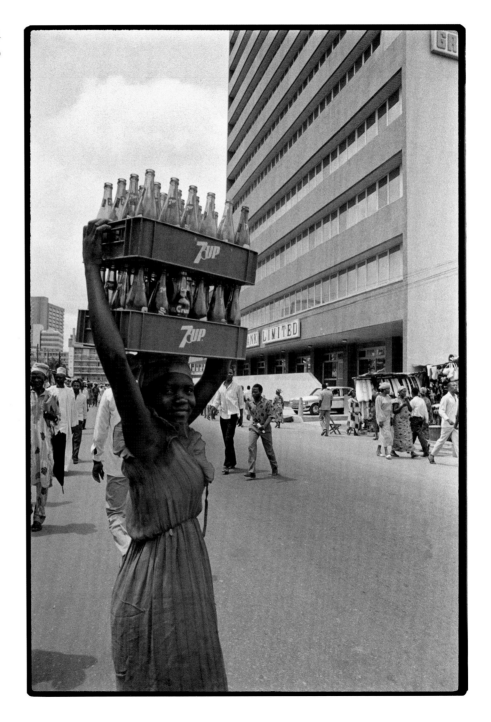

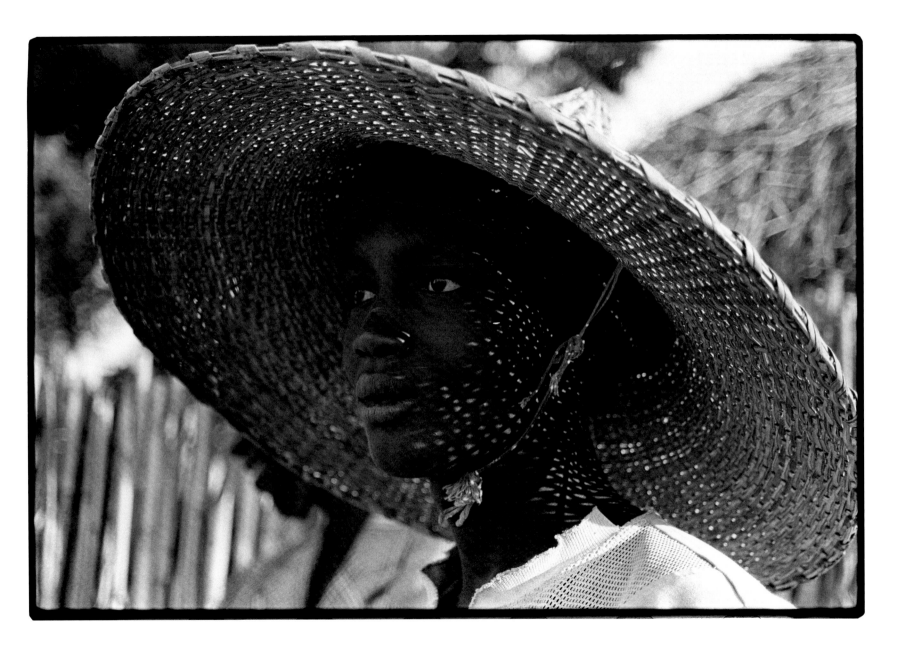

Strength of mind strengthens the body.
African proverb

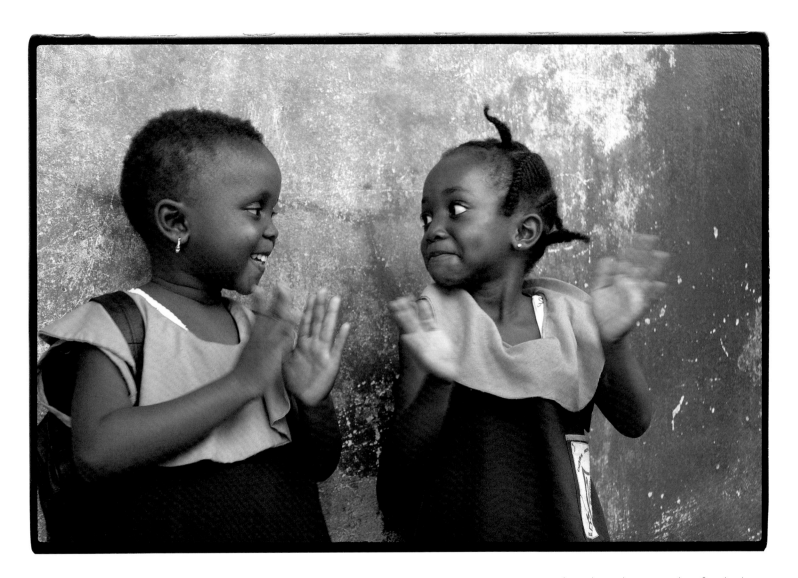

Laughter does wonders for the heart.
North African proverb

Life has two legs: male and female.
African proverb

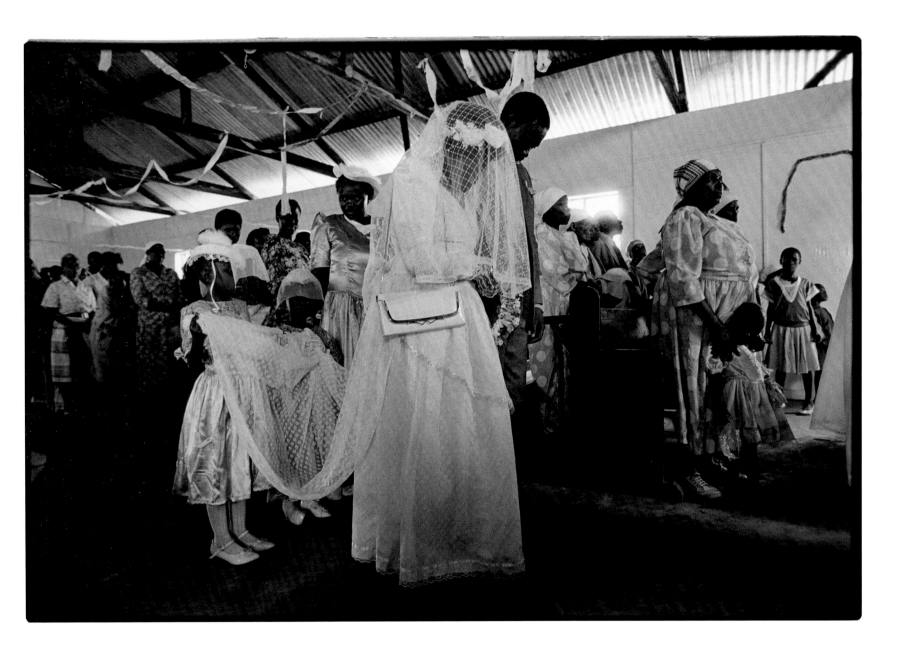

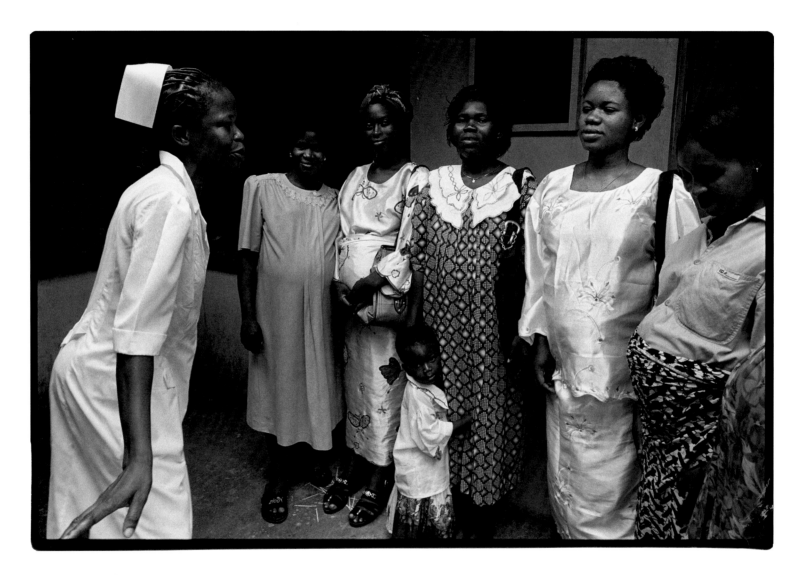

Every cackling hen was an egg at one time.
Burundian proverb

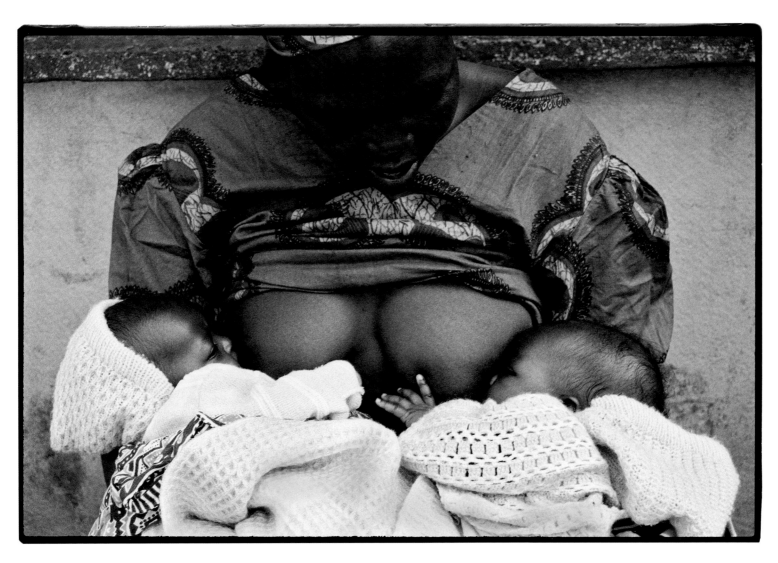

The mother with twins must have the milk.
Kenyan proverb

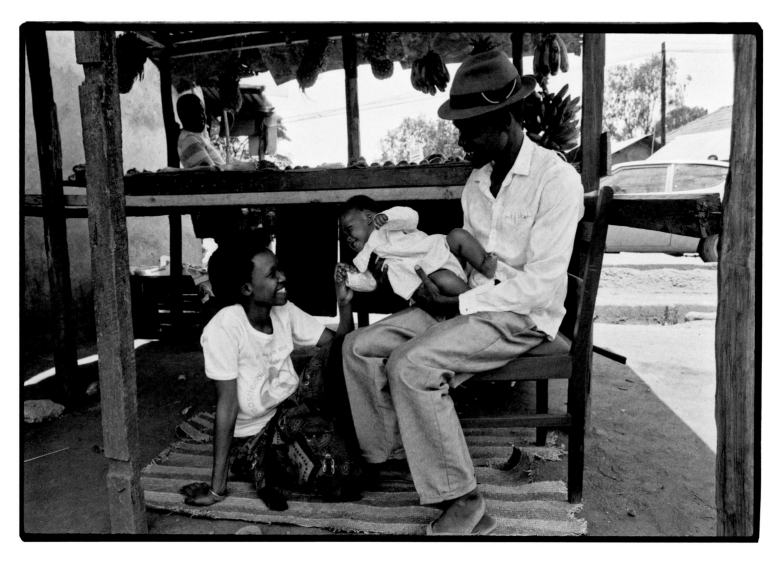

Home is where life is found in all its fullness.
Nigerian proverb

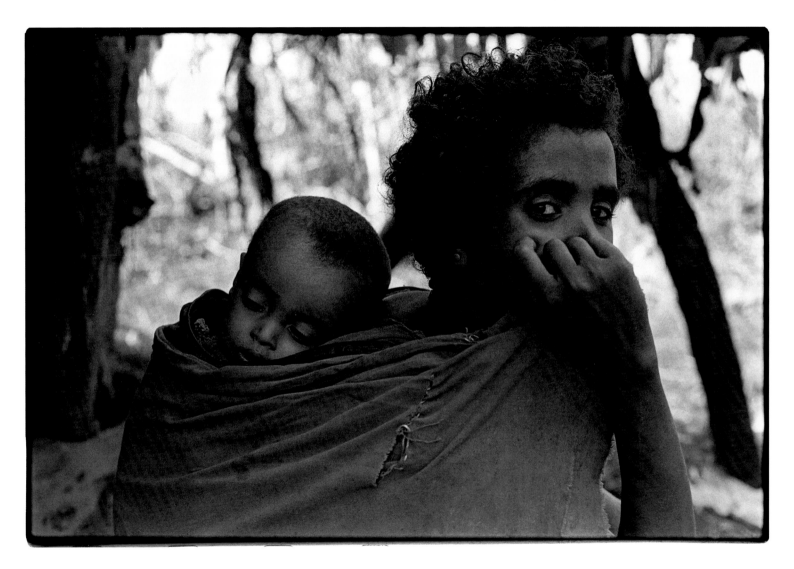

The burden of bearing is paid by the born.
African proverb

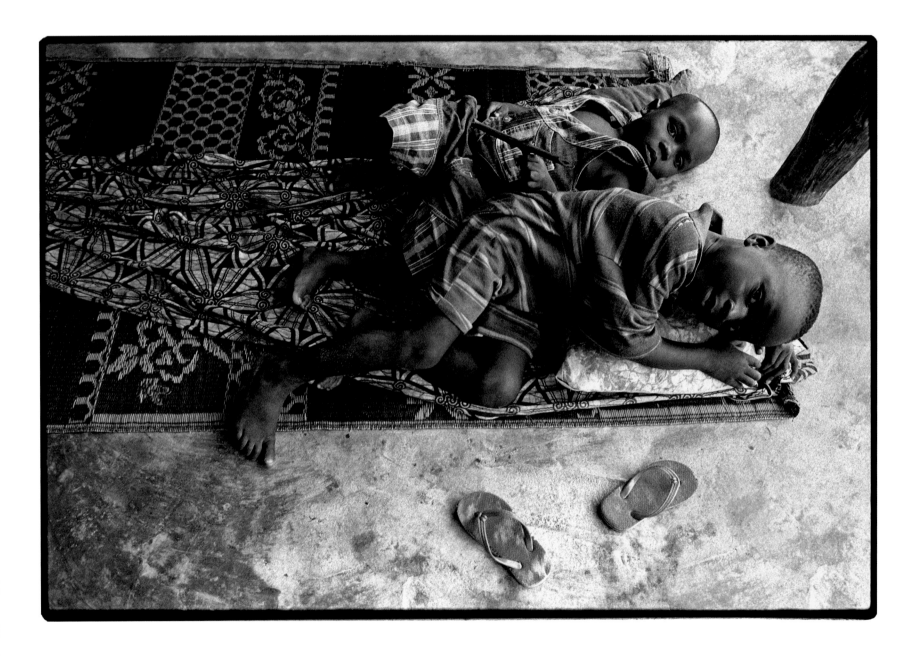

Look at your children to see their questions before they ask them.
Namibian proverb

A moral foundation is built in the home and refined outside.

Nigerian proverb

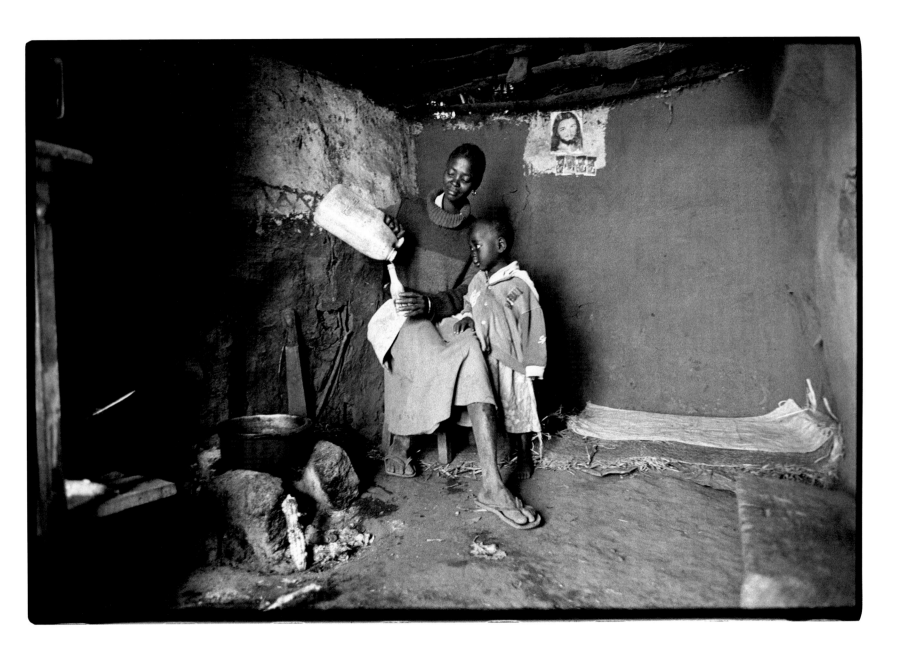

Children are the joy of the world.
African proverb

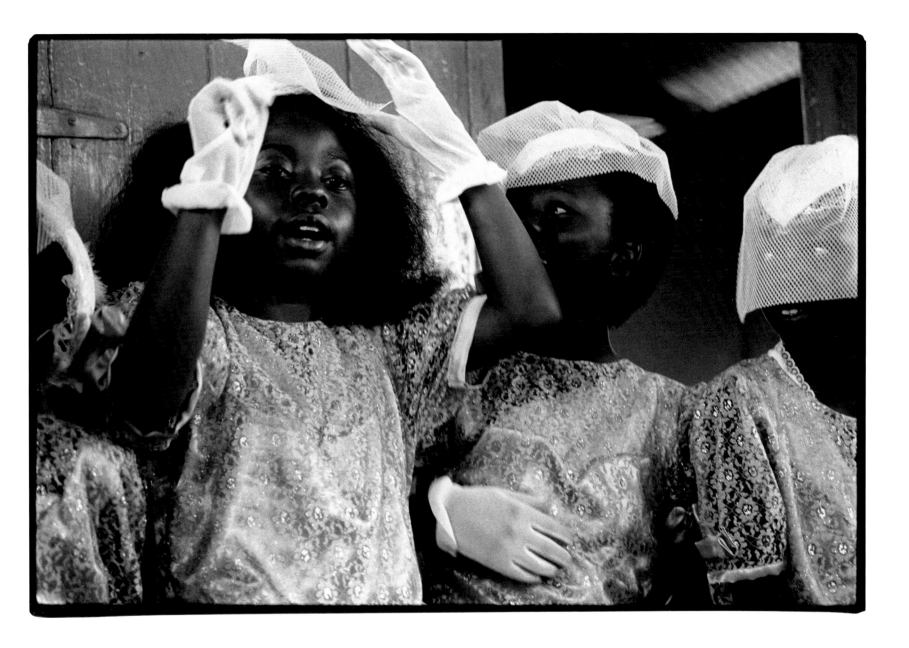

A child is a store; what you
tell her, she keeps.
Ugandan proverb

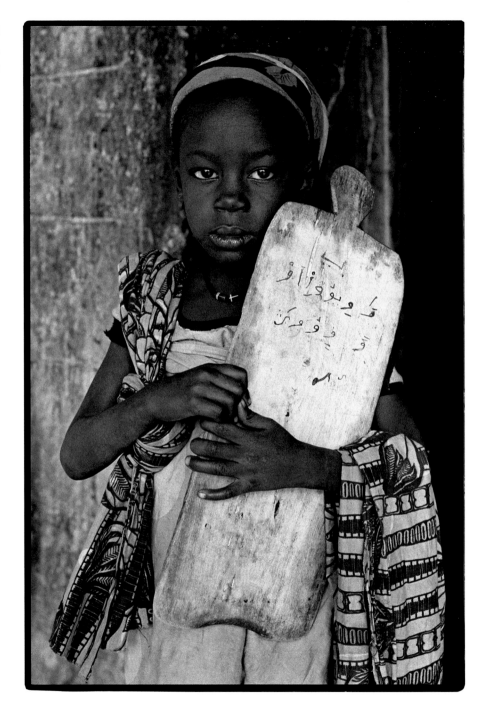

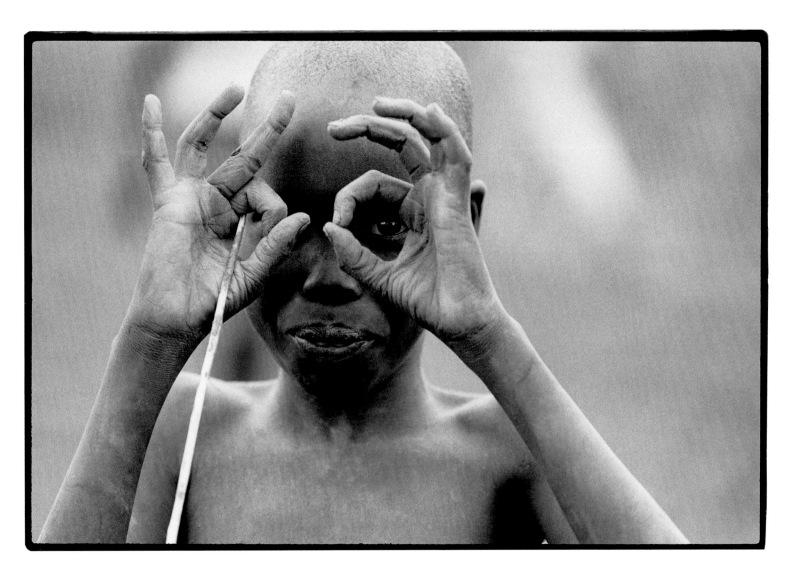

When a child behaves like an adult he sees what an adult sees.
African proverb

Our children are living messages sent to a future we may never see.
Nigerian proverb

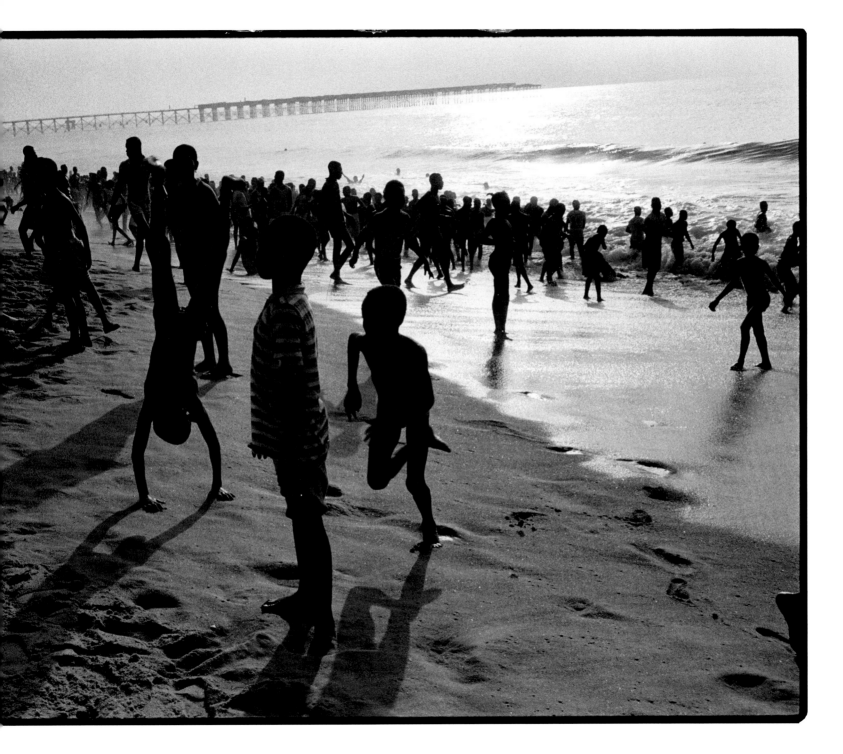

An uninitiated man is a child.

Kenyan proverb

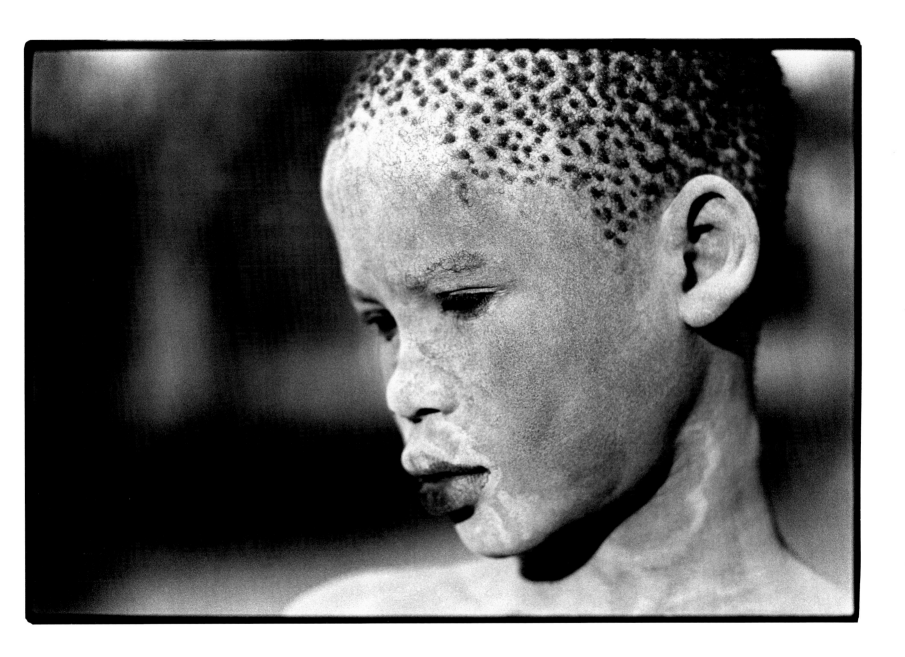

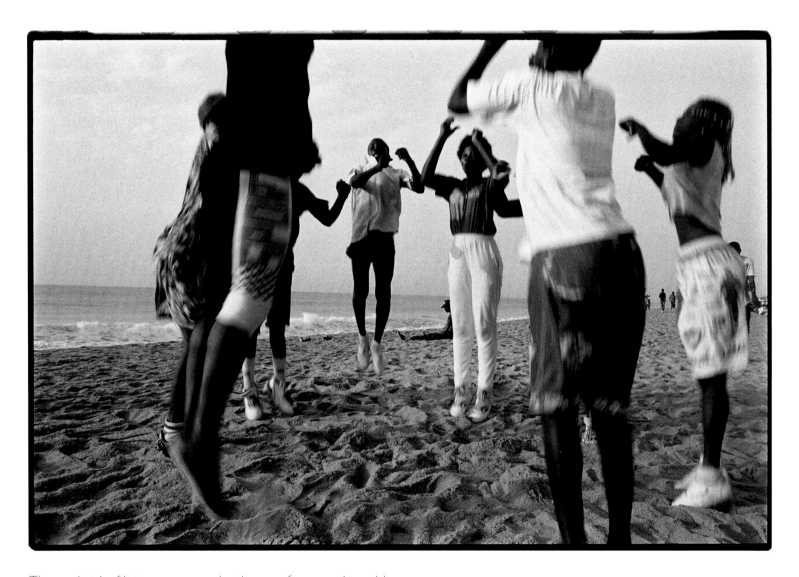

The yardstick of living measures the distance from youth to old age.
African proverb

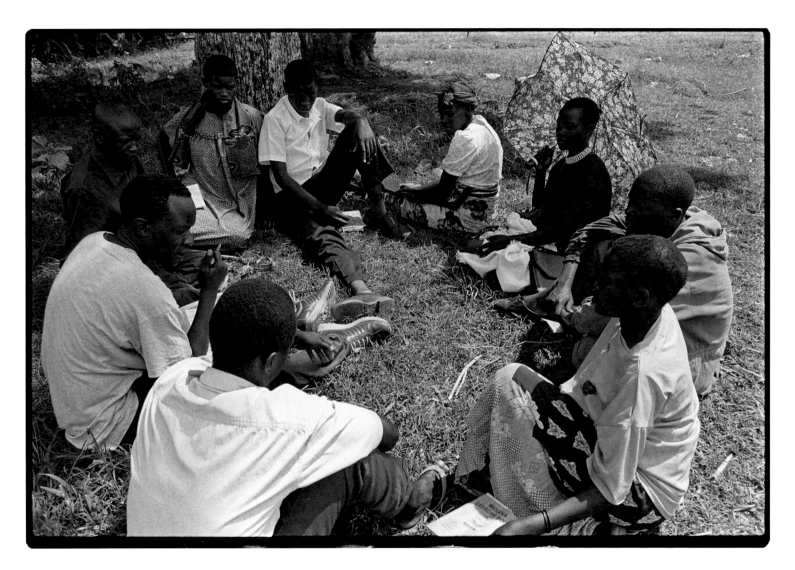

Today's youth are the future nation.
Zambian proverb

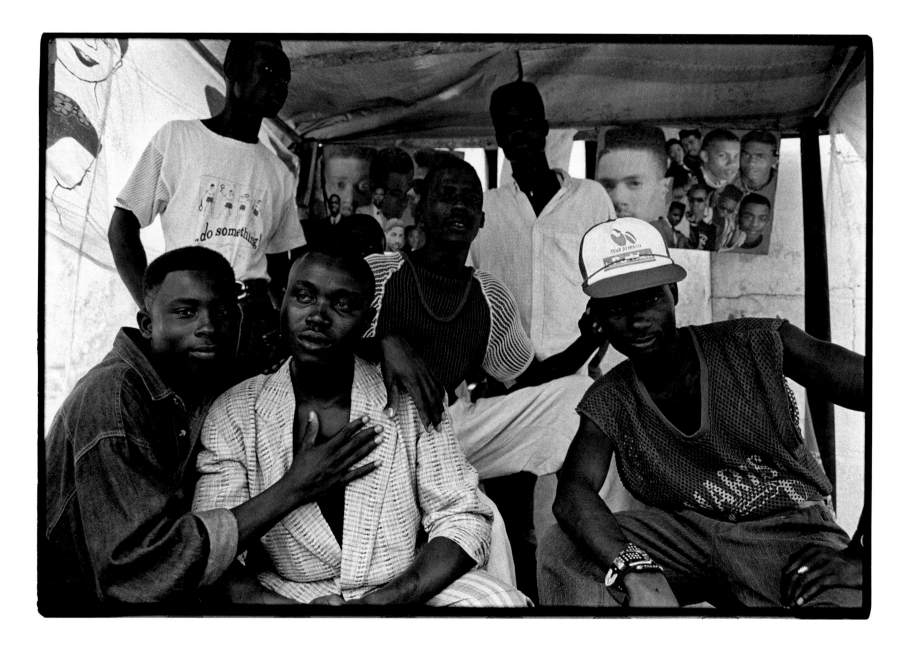

One's generation is like a different country to another's generation.
African proverb

Without craziness, one does not live.
Tanzanian proverb

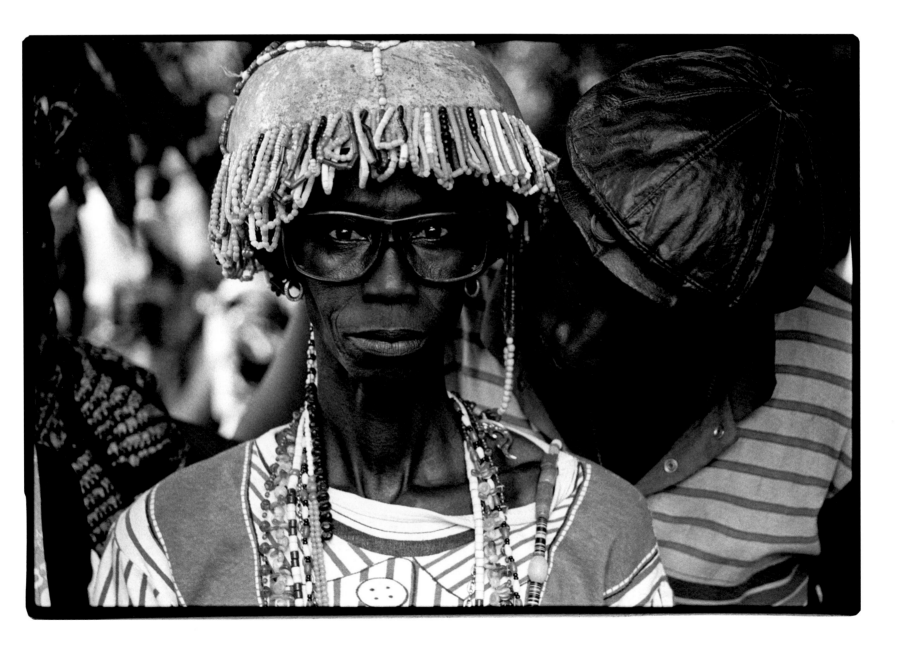

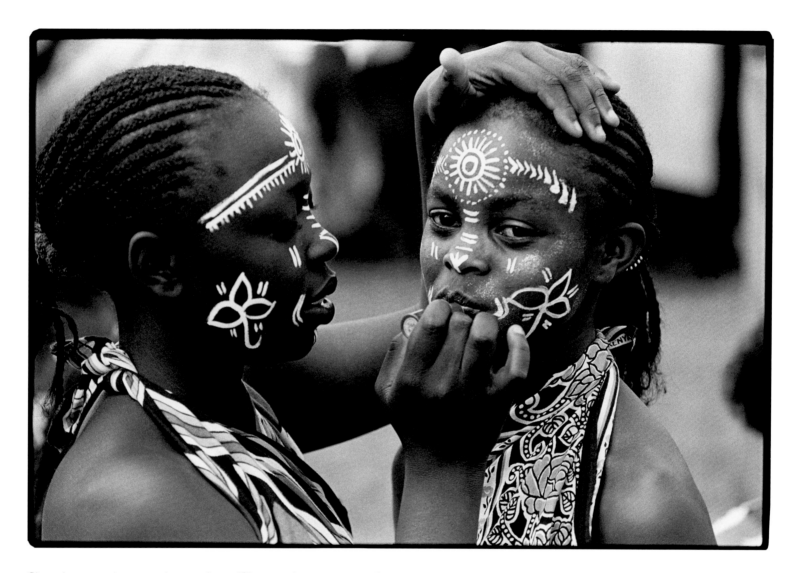

She who spends time adorning herself knows she is going to dance.
Kenyan proverb

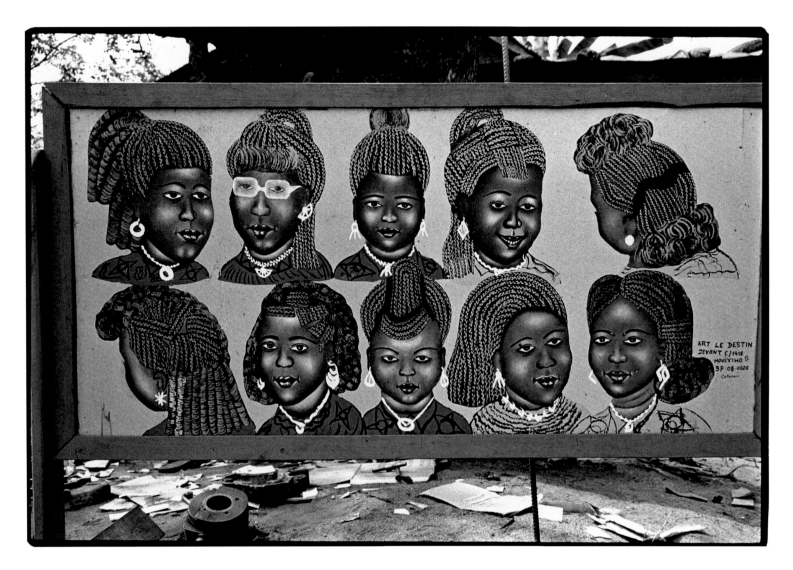

The hairdo is fashioned according to the head.
Ugandan proverb

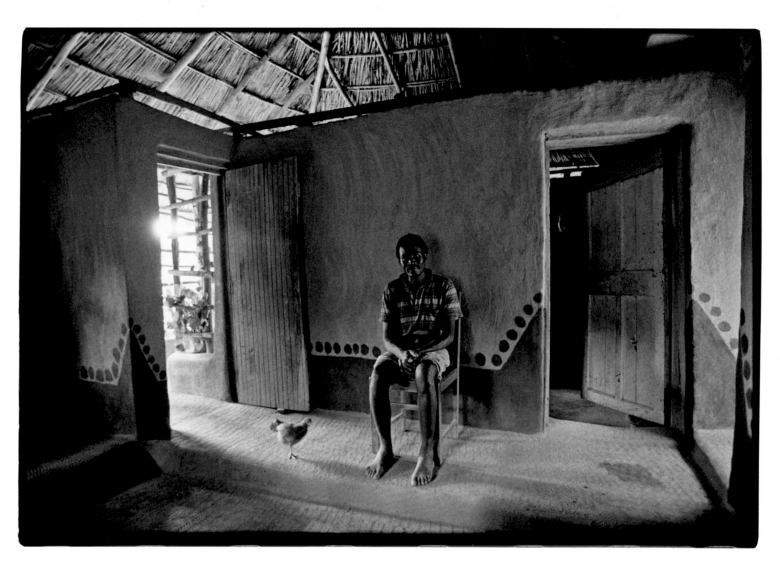

Living is worthless for one without a home.
Ethiopian proverb

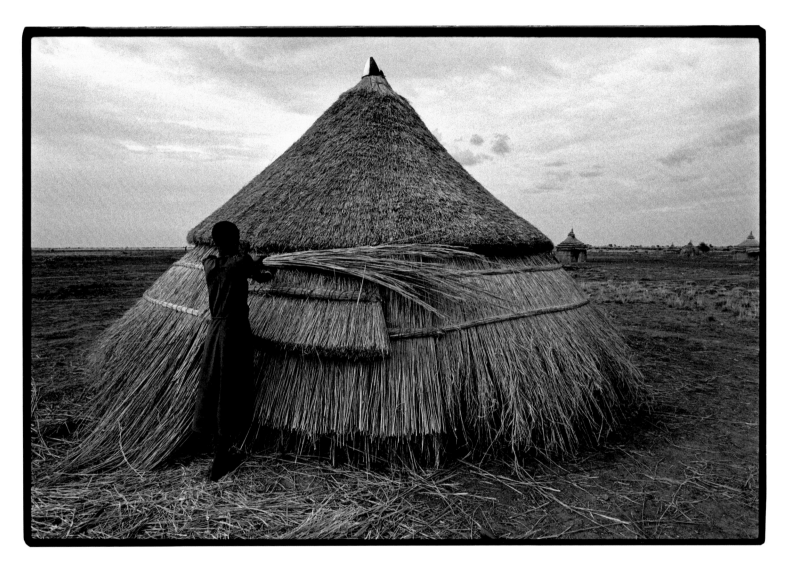

A house conceals many things.
African proverb

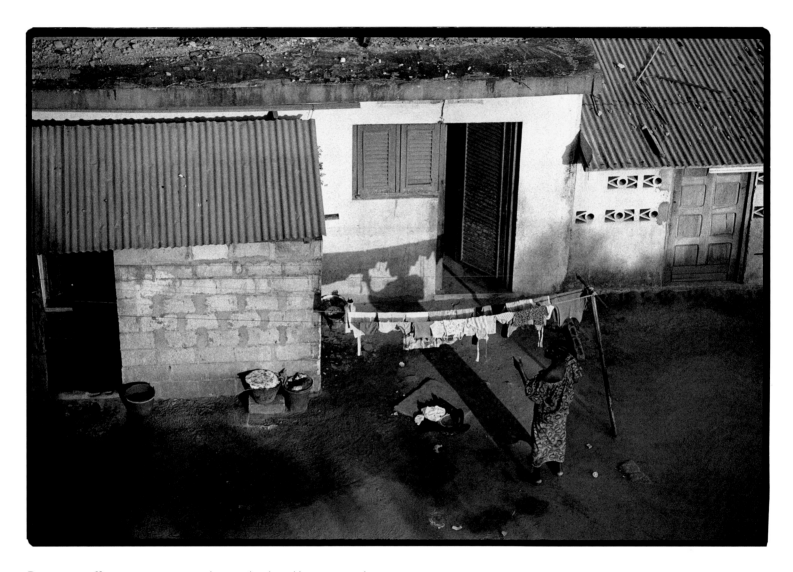

Domestic affairs are not rags to be washed and hung outside.
Ghanaian proverb

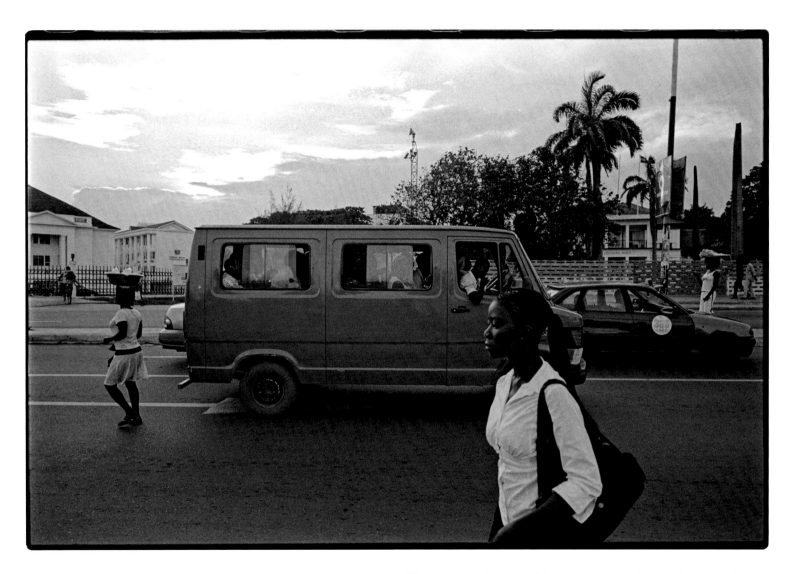

The town is a barren wilderness to one who is unhappy at home.
Nigerian proverb

To come out of one's home means learning.
Kenyan proverb

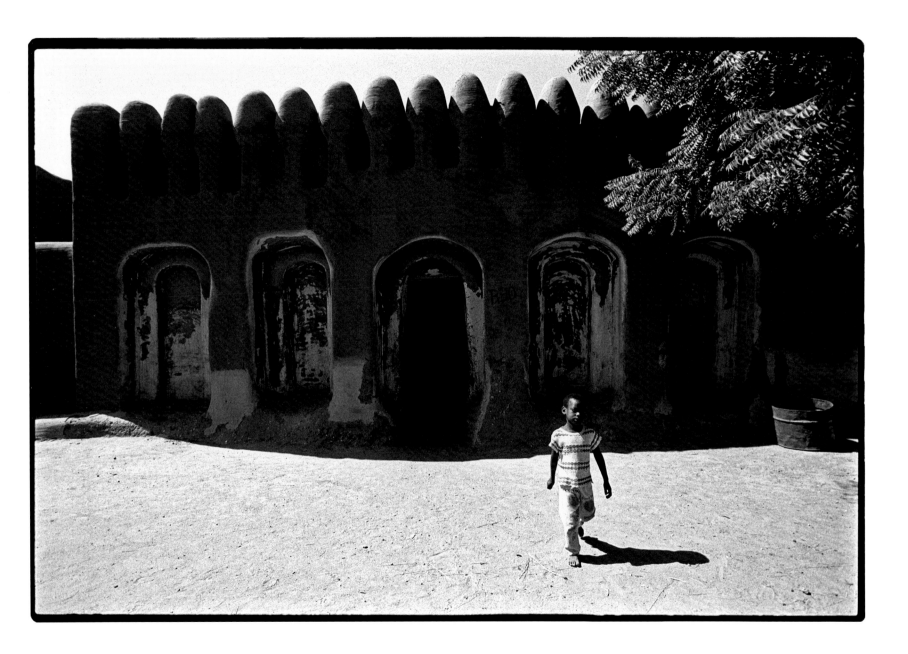

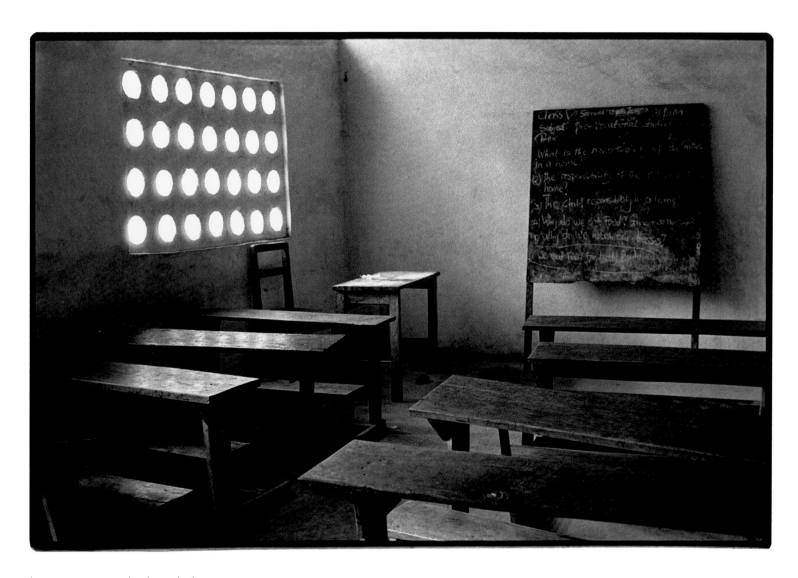

Ignorance precedes knowledge.
Congolese proverb

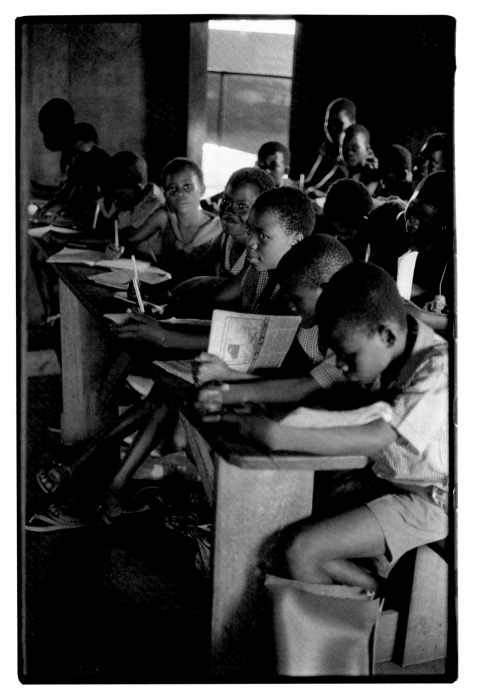

Knowledge is like a garden; if it is not cultivated, it cannot be harvested.
Guinean proverb

One can think best when at rest.
North African proverb

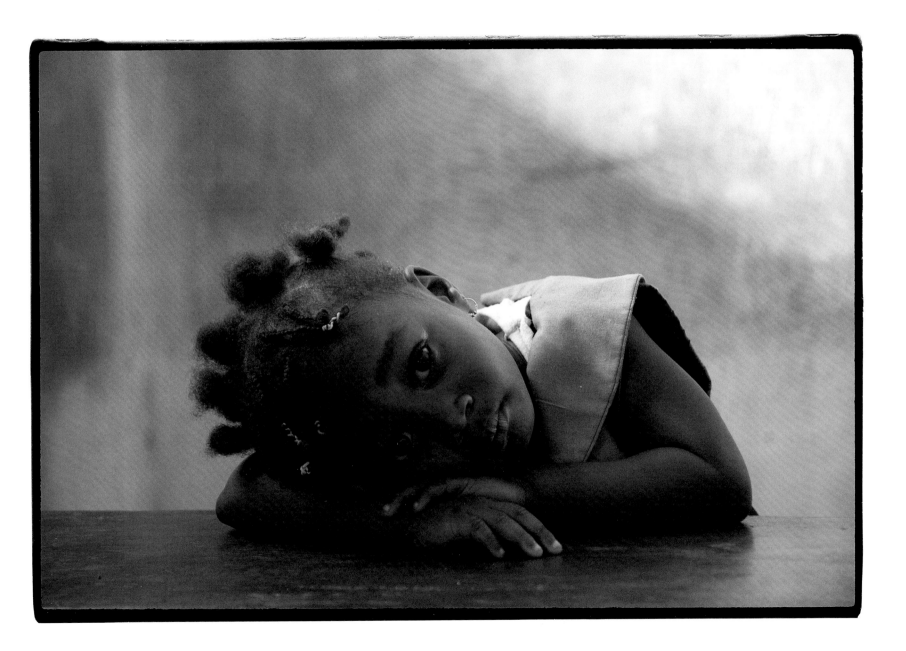

What you help a child to love is more important than what you help her to learn.
Senegalese proverb

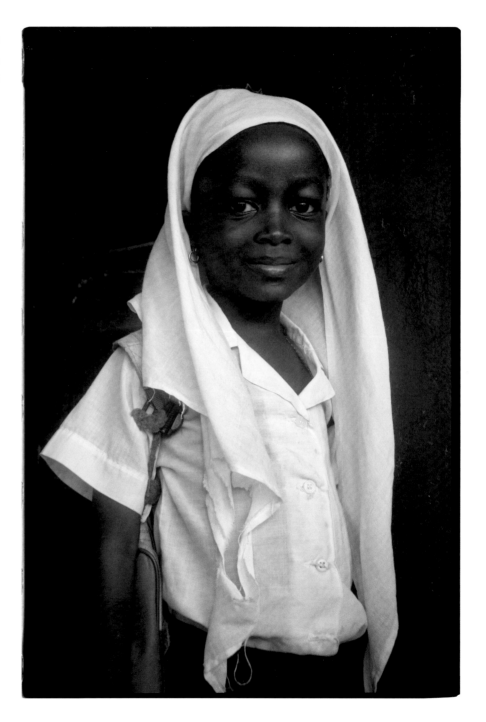

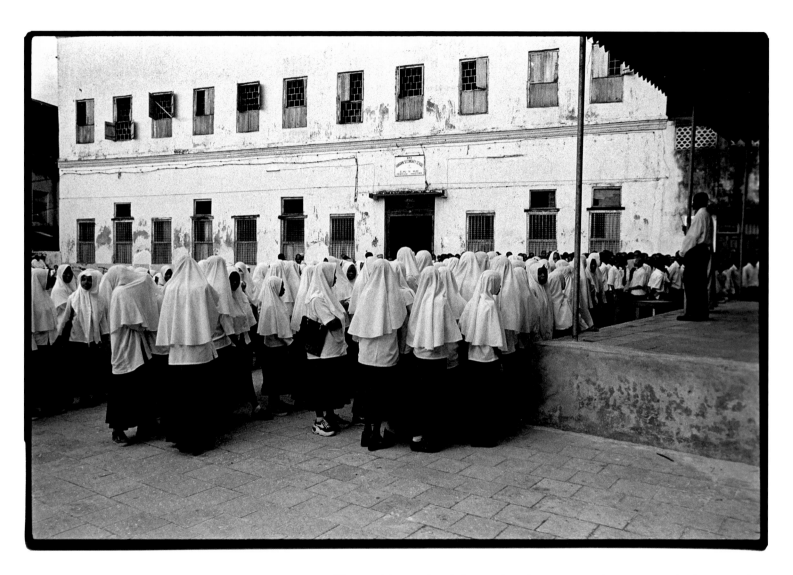

The world is a school, the earth a classroom and experience the best teacher.
Nigerian proverb

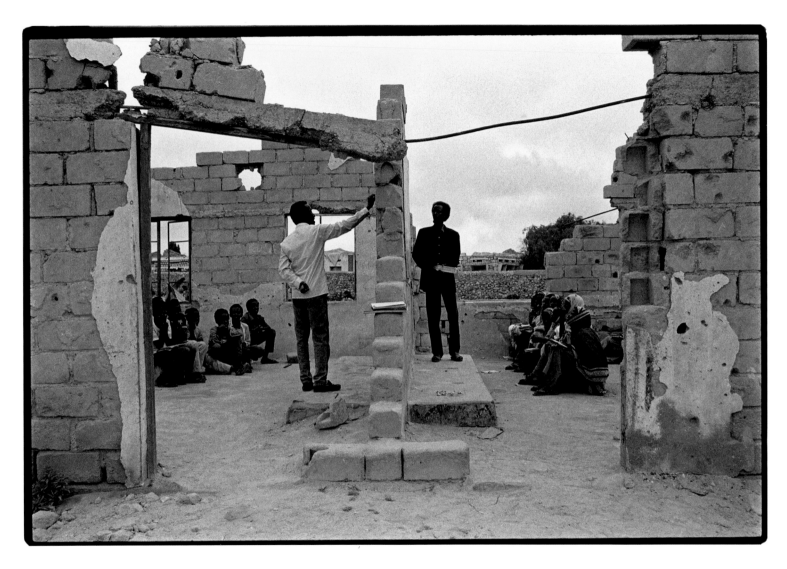

Struggle for knowledge.
Kenyan proverb

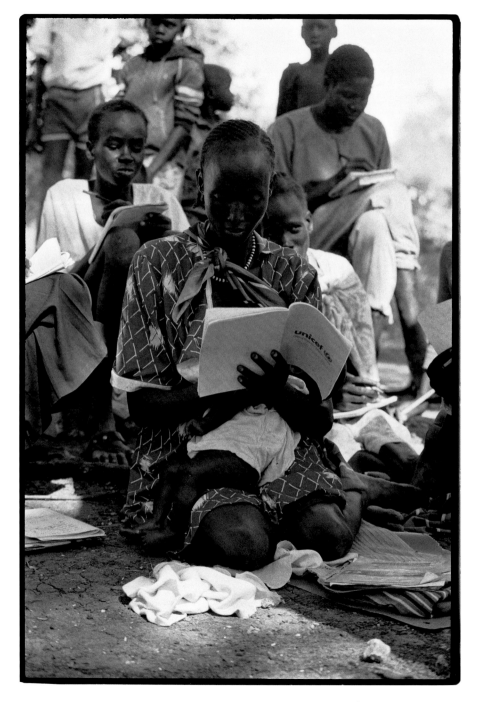

If you educate a man you educate an individual, but if you educate a woman you educate a family (nation).
Ghanaian proverb

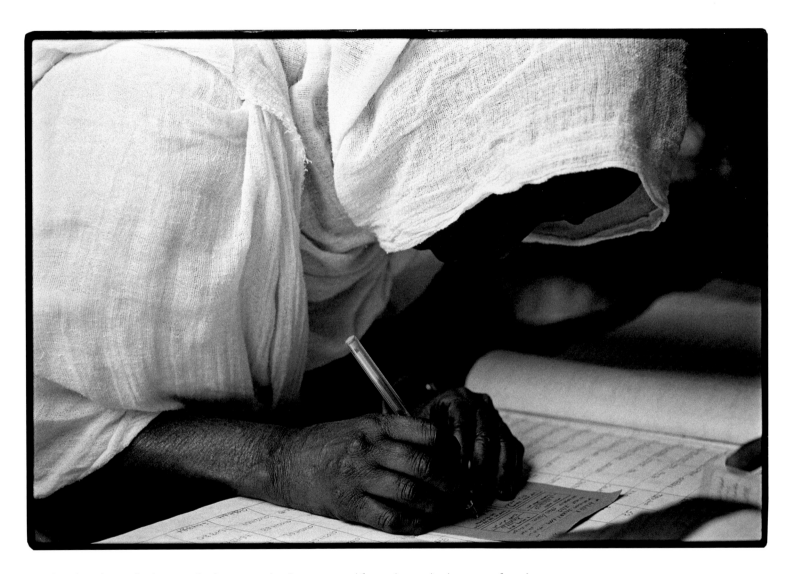

In school we learn the lessons before we take the exam; in life we learn the lessons after the exam.
Ghanaian proverb

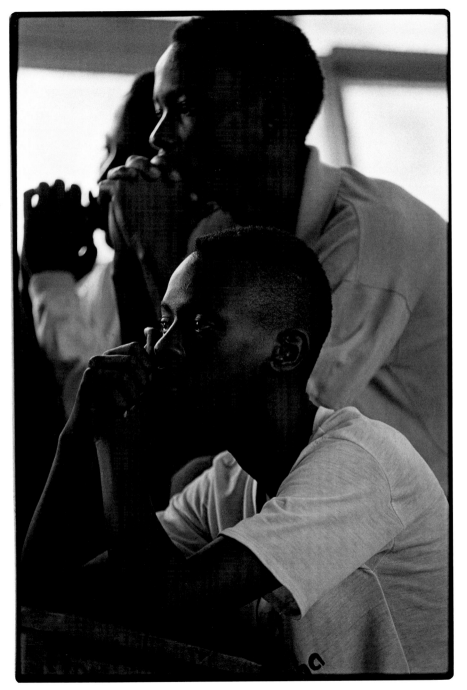

A listening ear leads to life but
a deaf ear leads to death.
Kenyan proverb

Traveling is learning.
Kenyan proverb

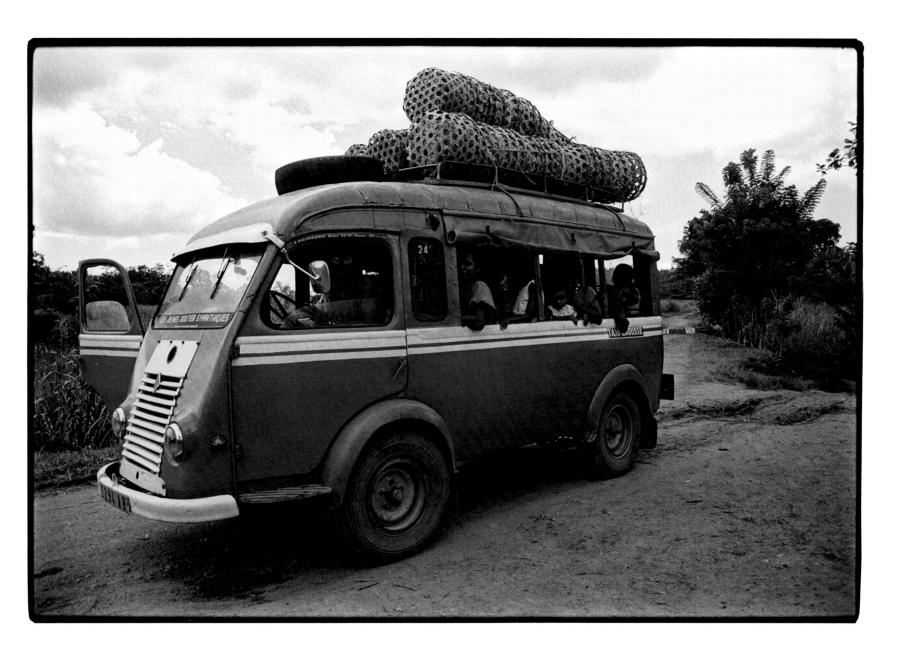

A good wind is no use to a sailor who does not know his direction.

Zambian proverb

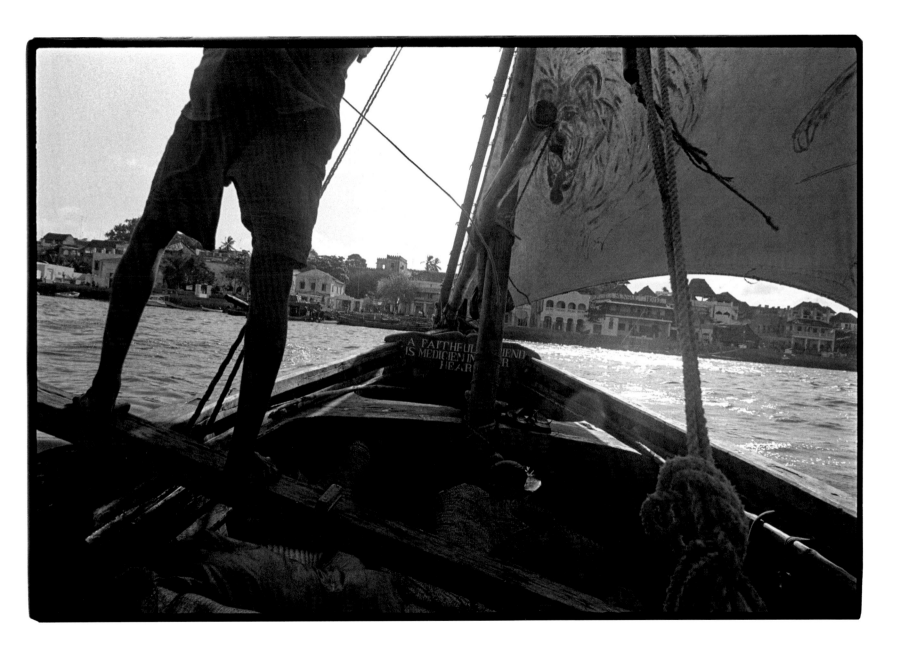

To dream means to look through the horizon.
African proverb

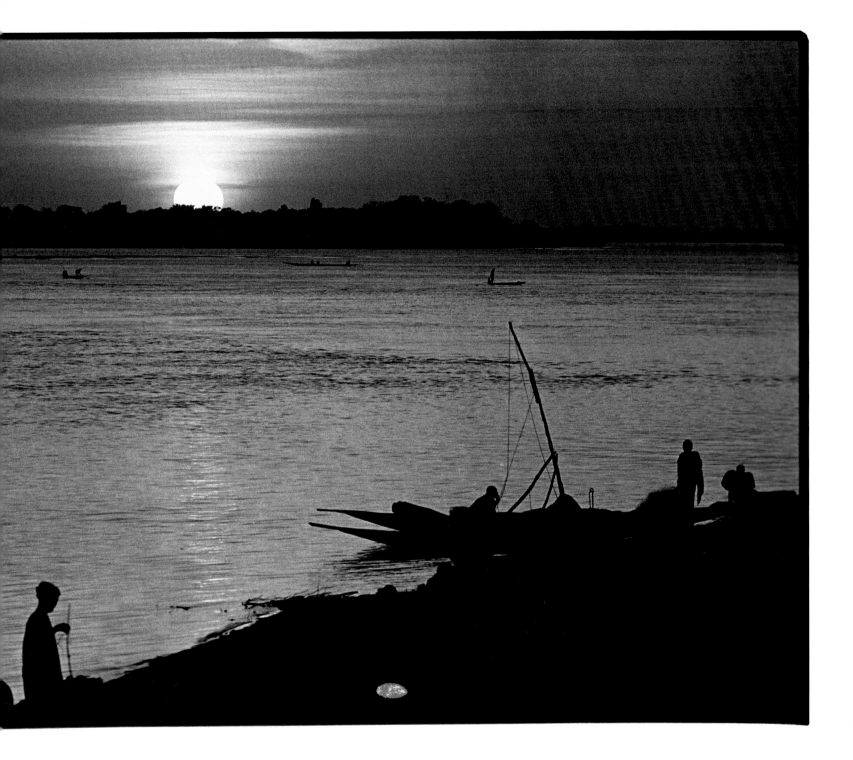

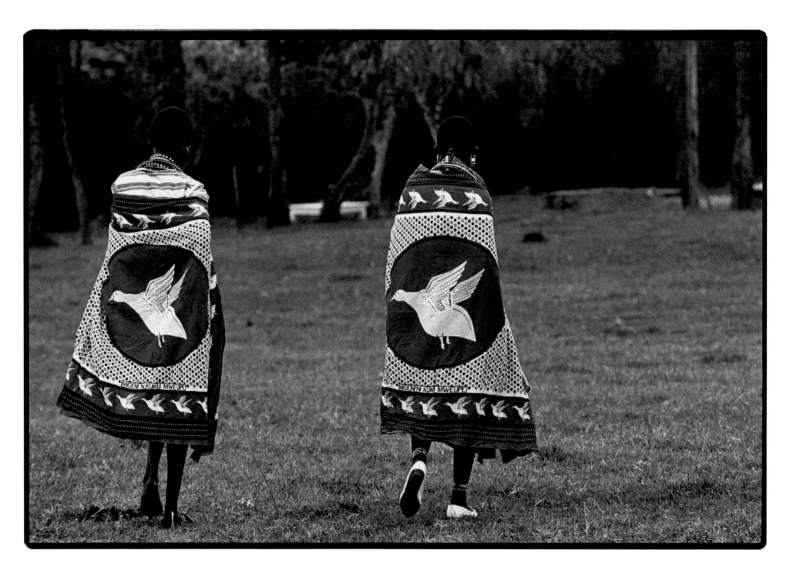

Only equals can be friends.
African proverb

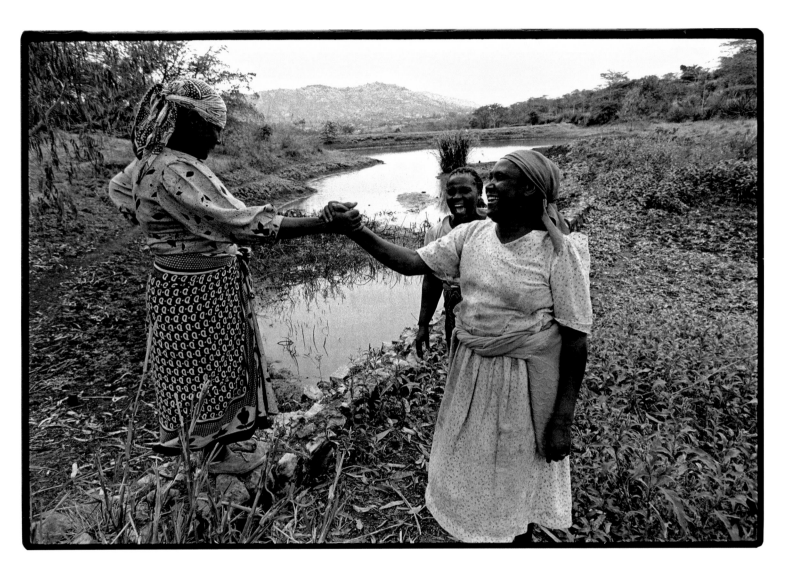

Do not meet a friend without greeting her.
Kenyan proverb

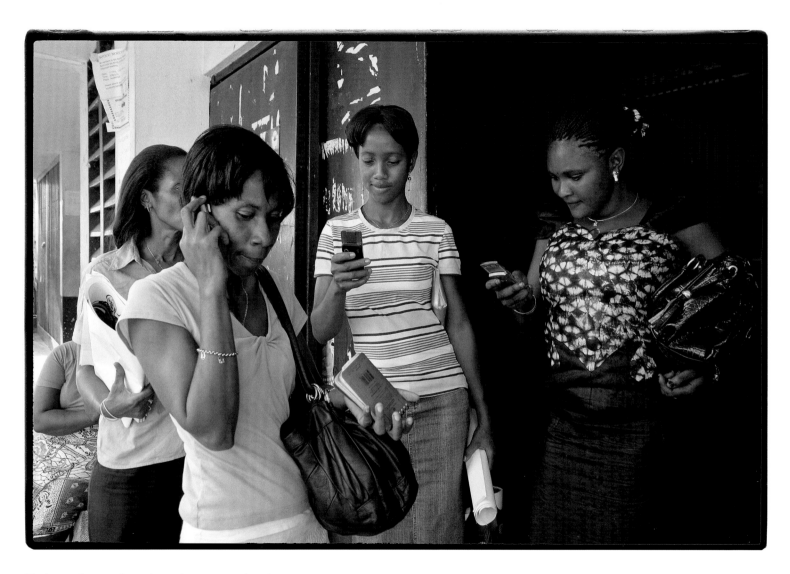

To be without a friend is to be poor indeed.
Somali proverb

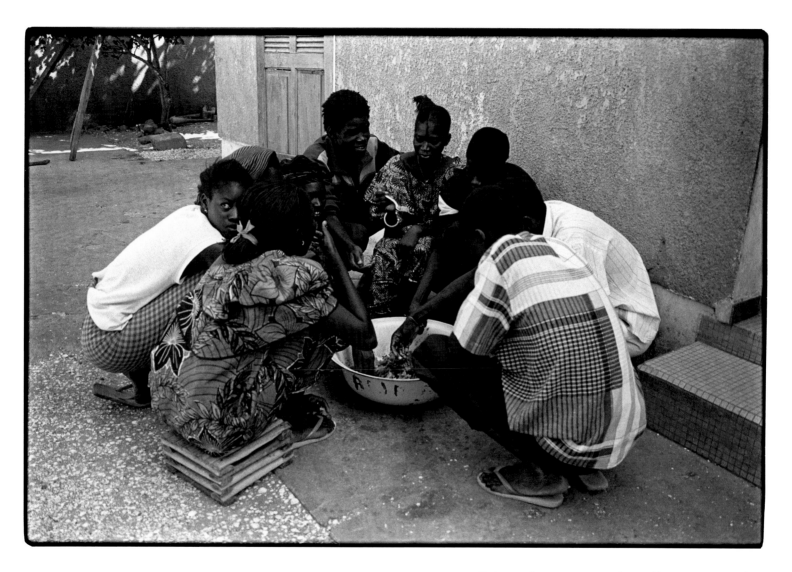

Relationships are strengthened by eating together.
Ugandan proverb

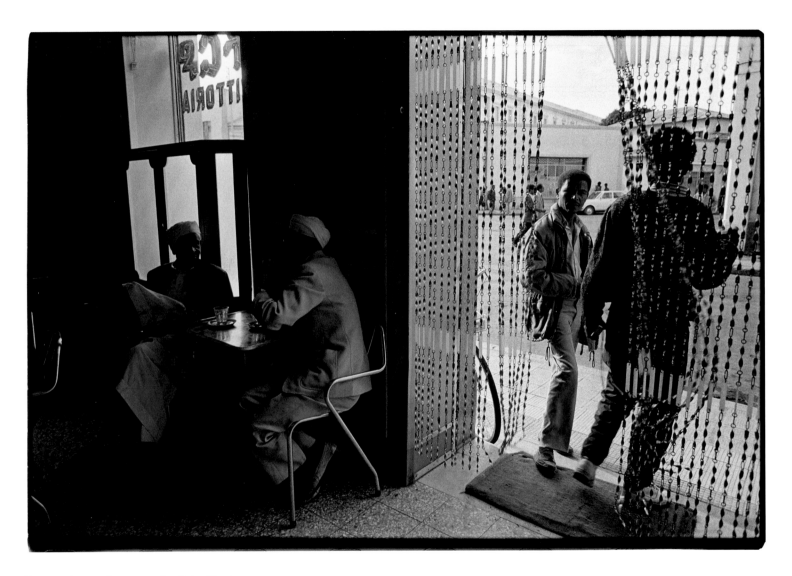

Every relationship is a gift of the Spirit.
African proverb

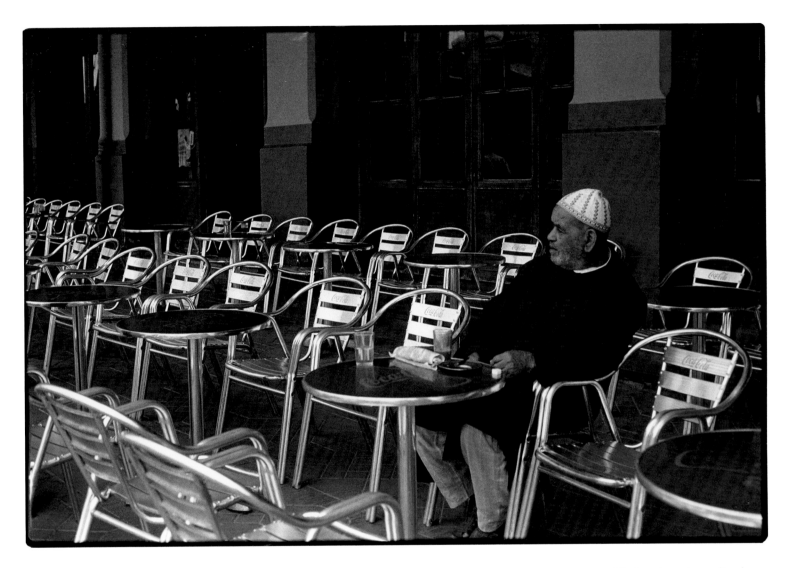

To be alone is to die alone.
African proverb

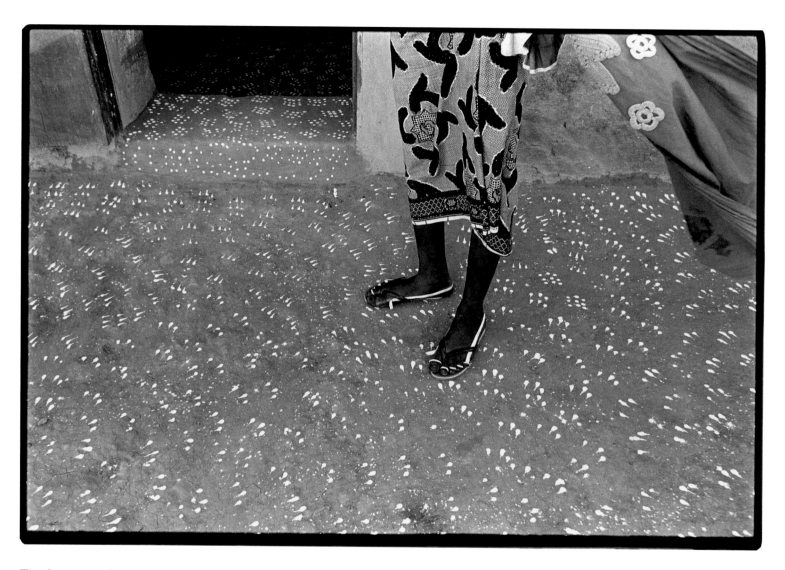

The footprint of one person is narrow.
Congolese proverb

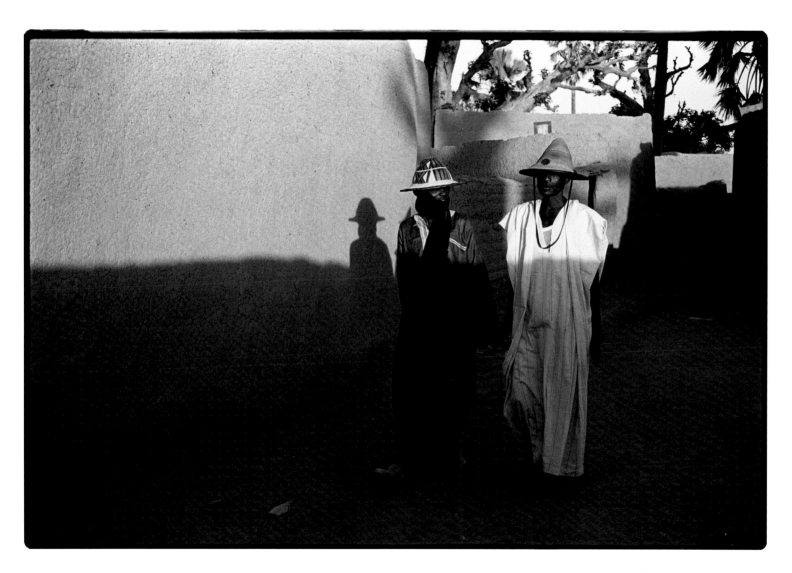

If you want to walk fast, walk alone; if you want to walk far, walk with others.
Zimbabwean proverb

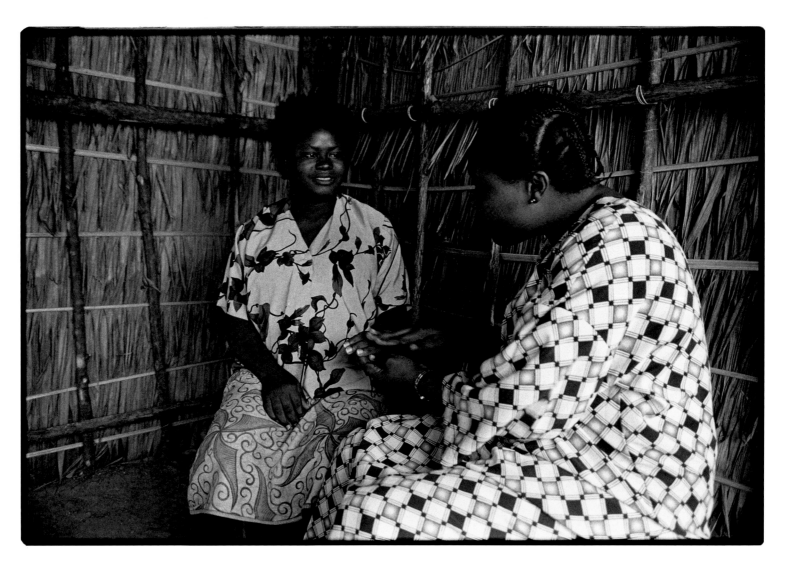

Gifts of love are gifts of life.
African proverb

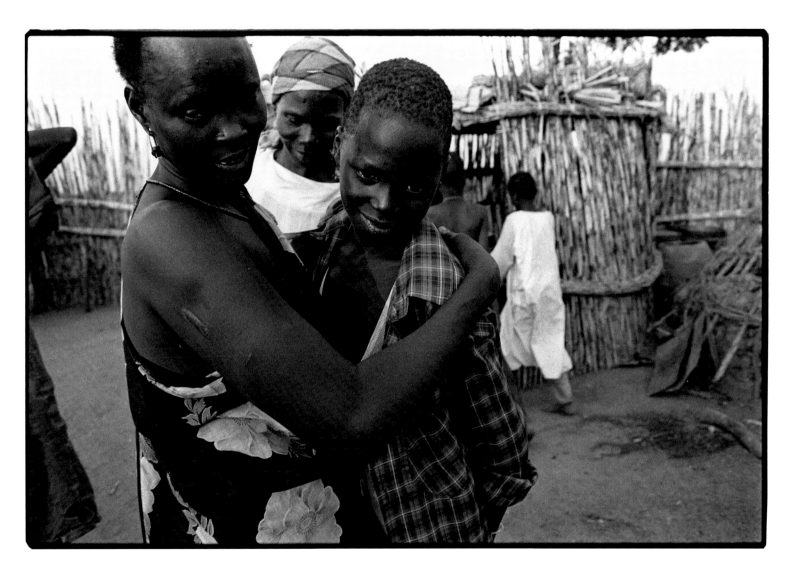

To protect an individual is to protect society.
Zambian proverb

The story of life is best told by deeds.
African proverb

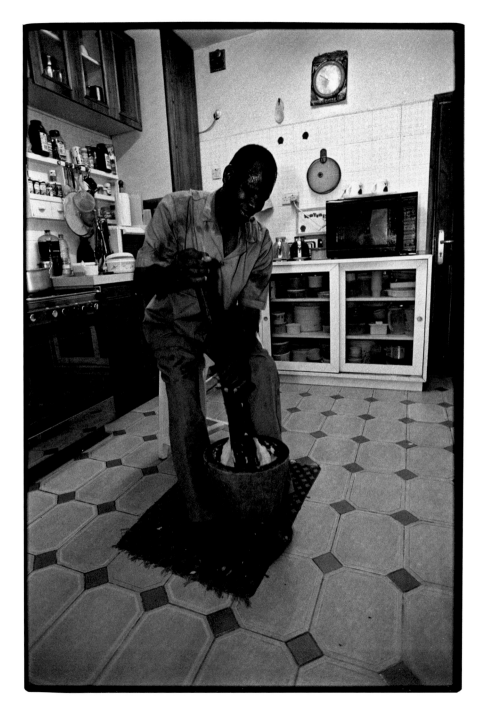

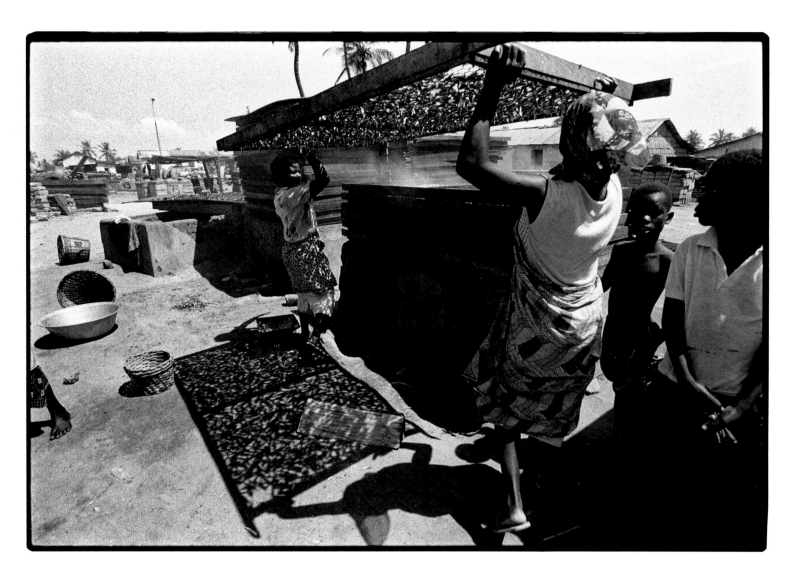

One does not live without working.
Tanzanian proverb

Work is the measure of a person.
Tanzanian proverb

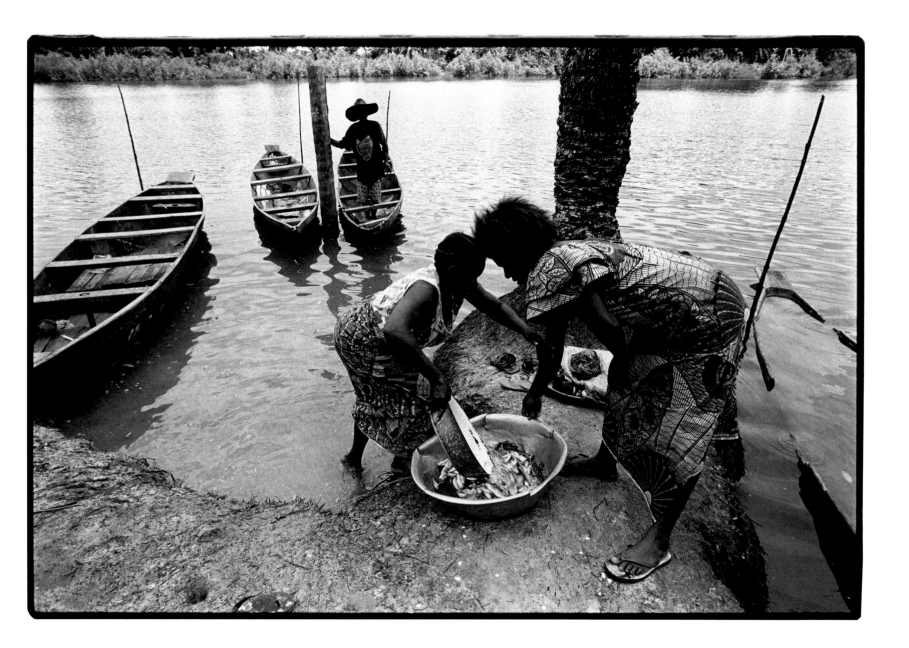

Work is good, provided you do not forget to live.
Kenyan proverb

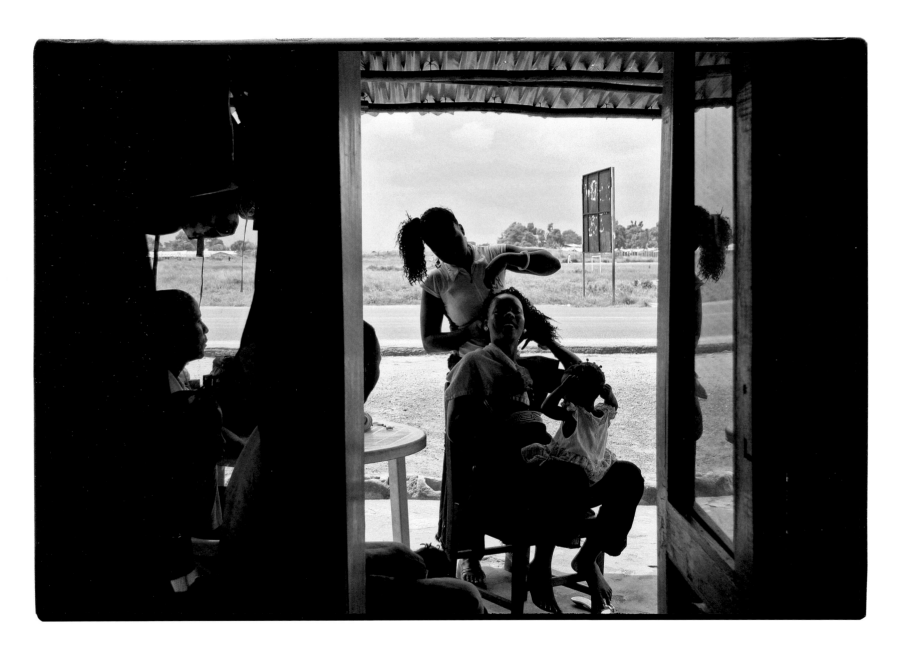

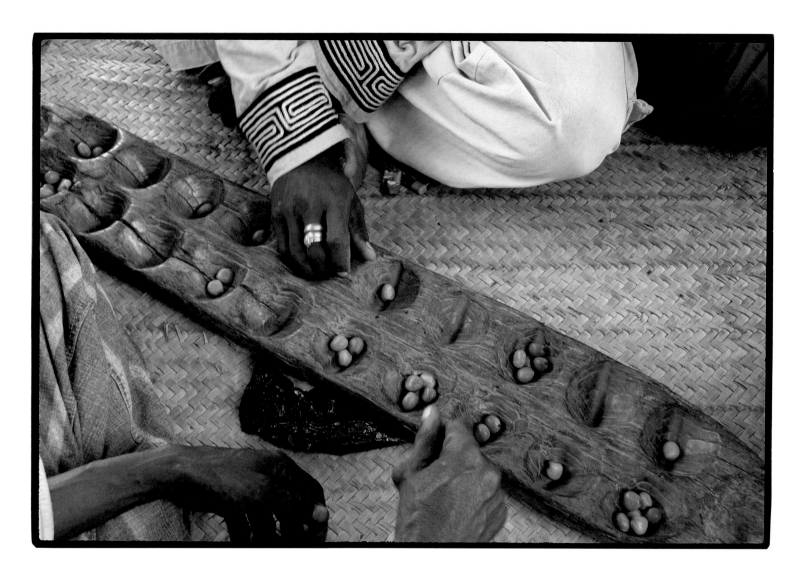

Life is a game.
Tanzanian proverb

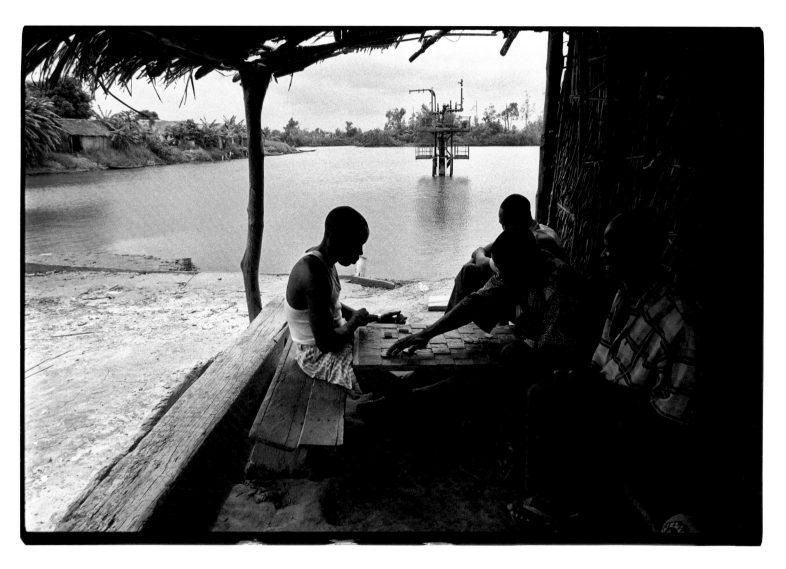

A day of relief amidst years of stress is like a day in paradise.
Nigerian proverb

The heart becomes tired and needs recreation.
North African proverb

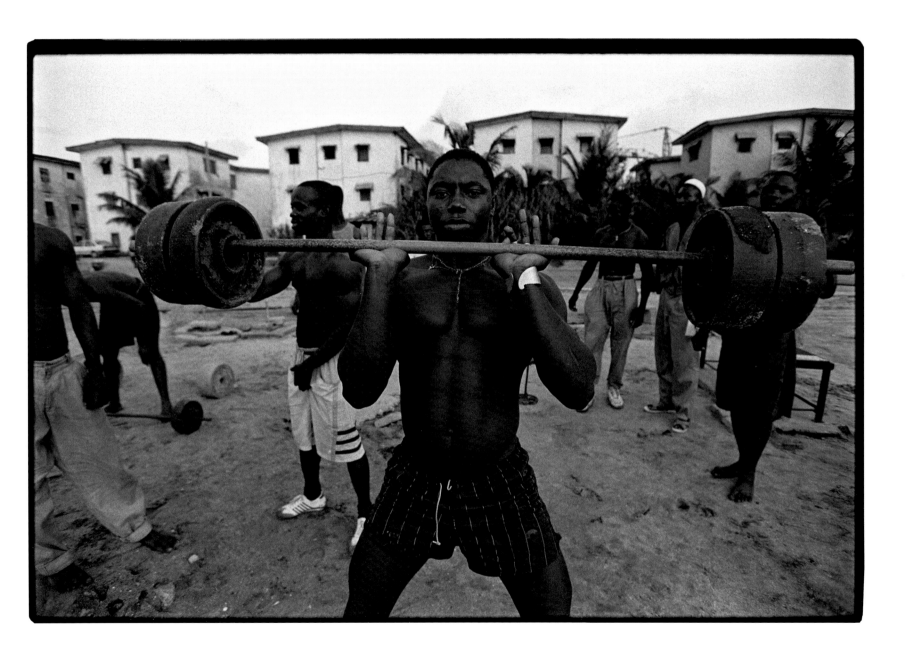

A calabash with holes cannot be filled.
Kenyan proverb

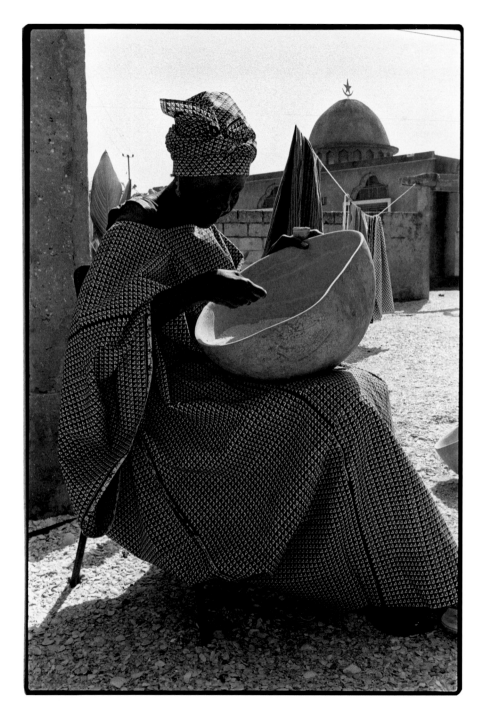

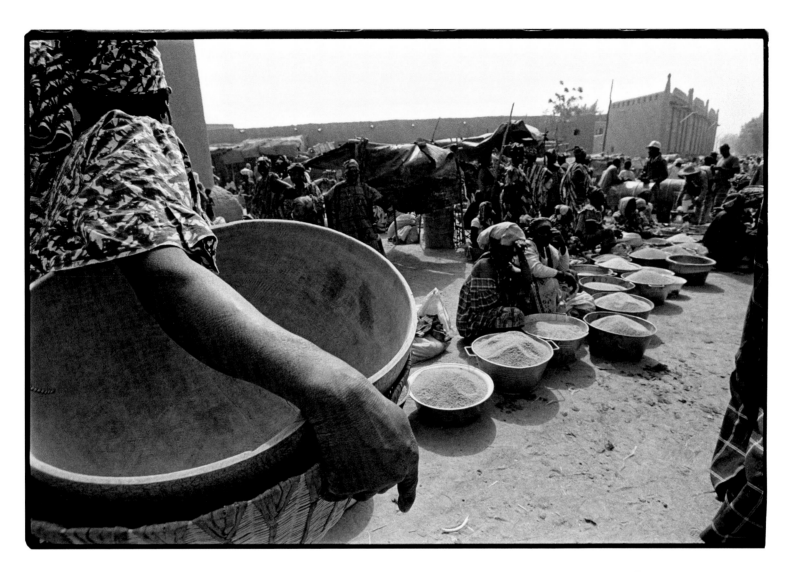

Life is all about exchange.
Burundian proverb

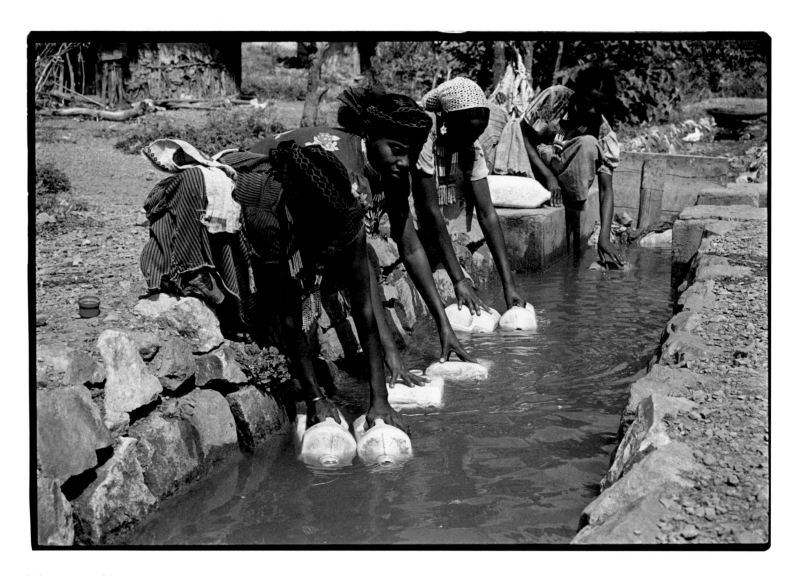

Water is wealth.
African proverb

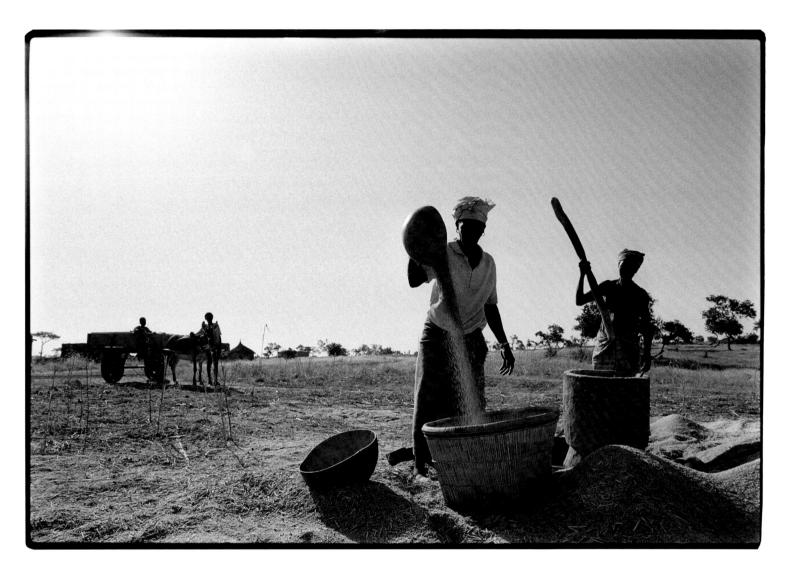

When you winnow finger millet, remember the birds.

African proverb

Go softly in the world; if it is harmed, it cannot return.
Nigerian proverb

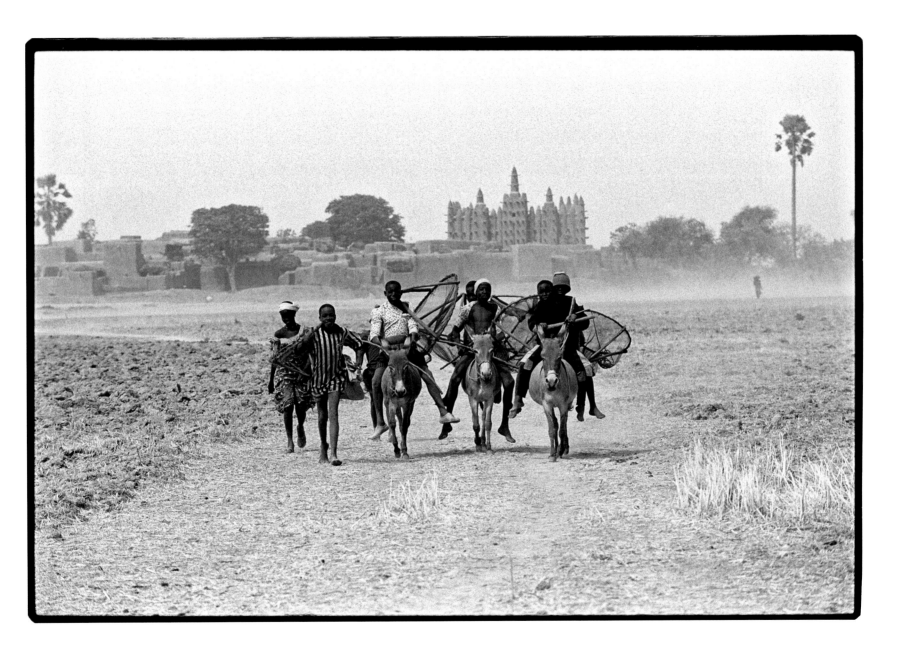

The earth is the mother of all.
Ugandan proverb

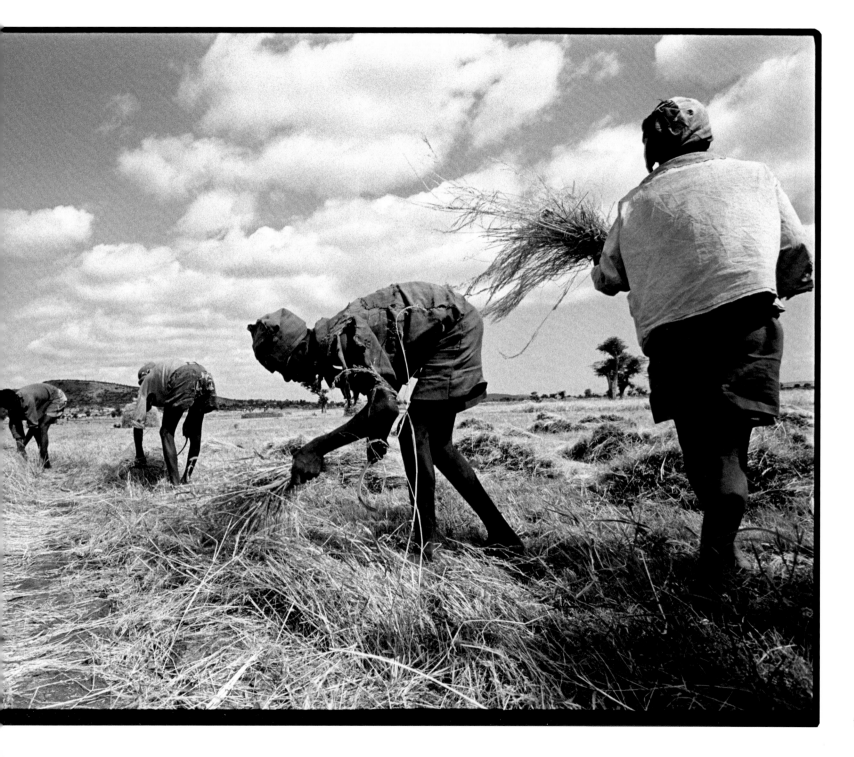

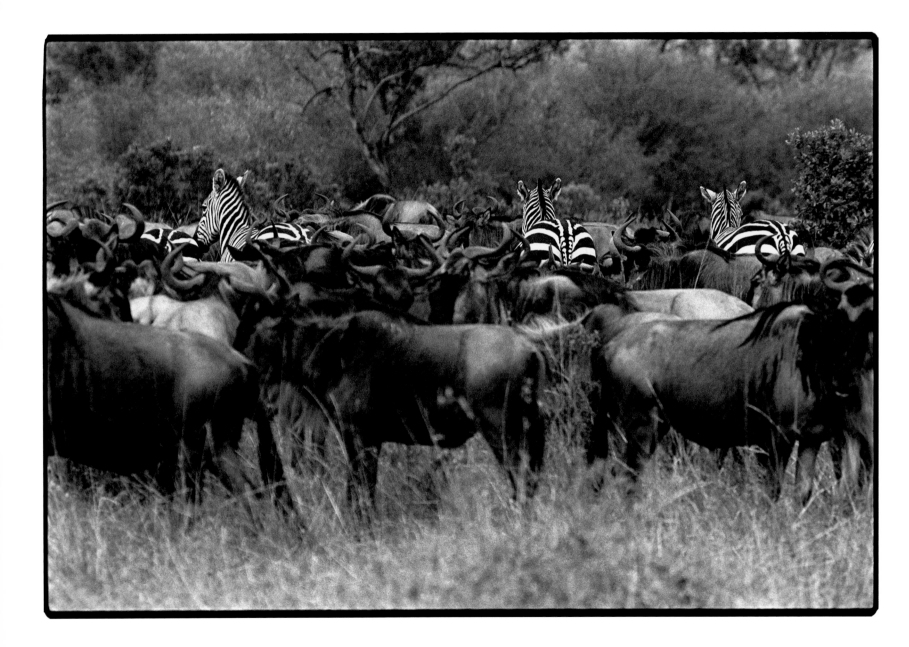

Treat the earth well; it was not given to you by your parents, but was loaned to you by your children.

Kenyan proverb

Not everything with a crooked neck is a camel.
North African proverb

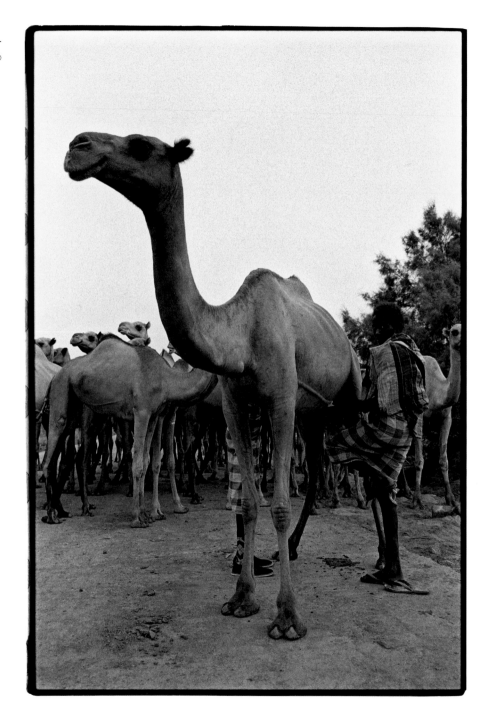

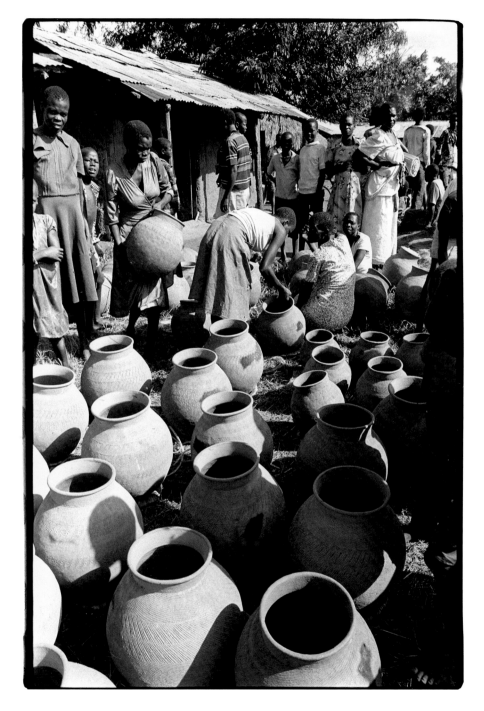

The pot that cooks food can cook poison.
African proverb

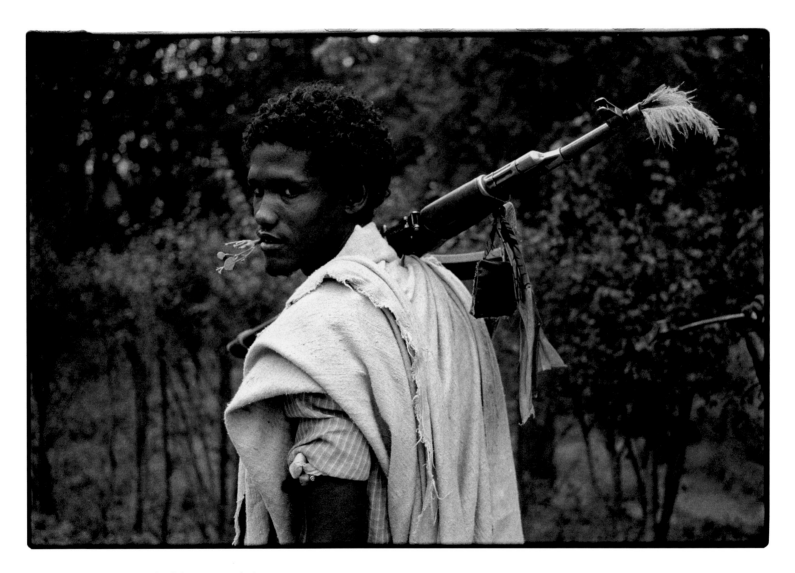

The inside of the barrel of the gun is dark.
Ugandan proverb

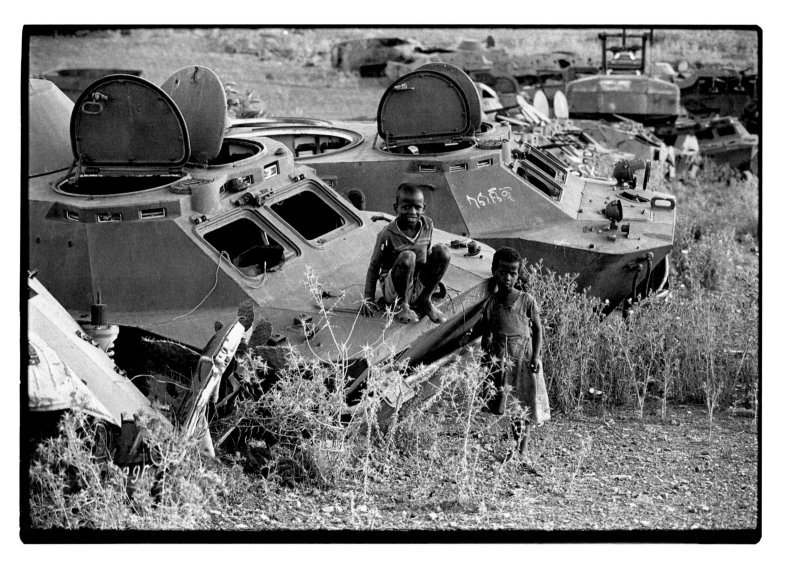

Those who have not died in war will start the next one.
African proverb

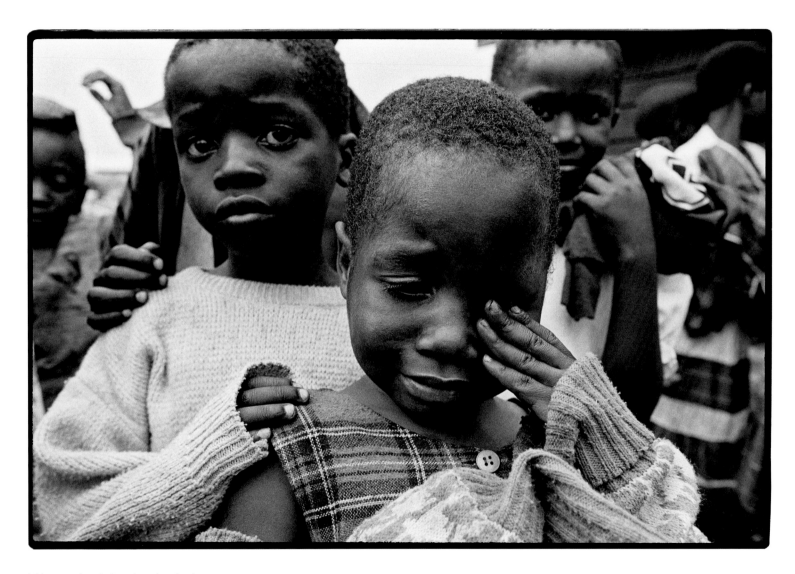

War is a bad chisel with which to carve out tomorrow.
Sierra Leonean proverb

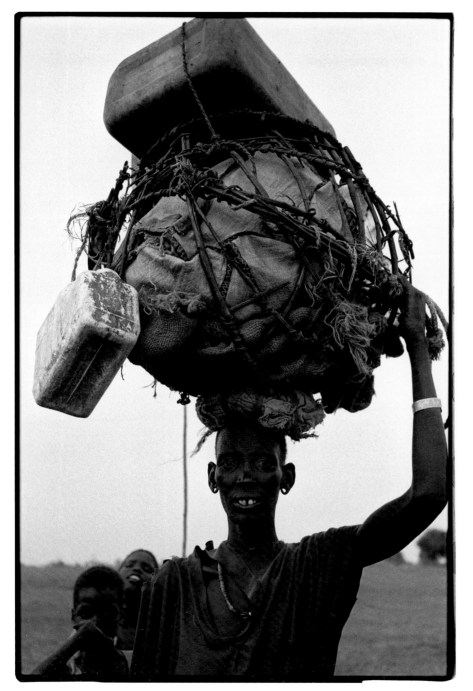

She who has not carried a load herself does not know how heavy it is.
Ugandan proverb

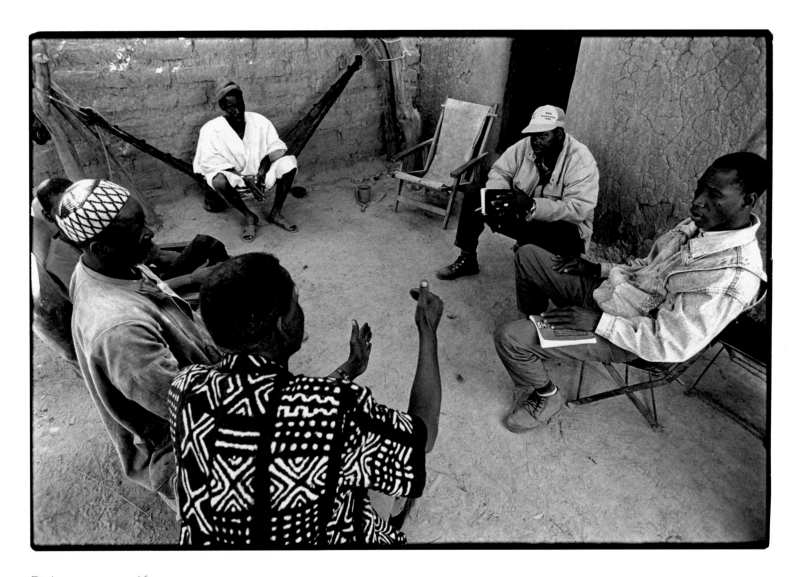

Dialogue protects life.
African proverb

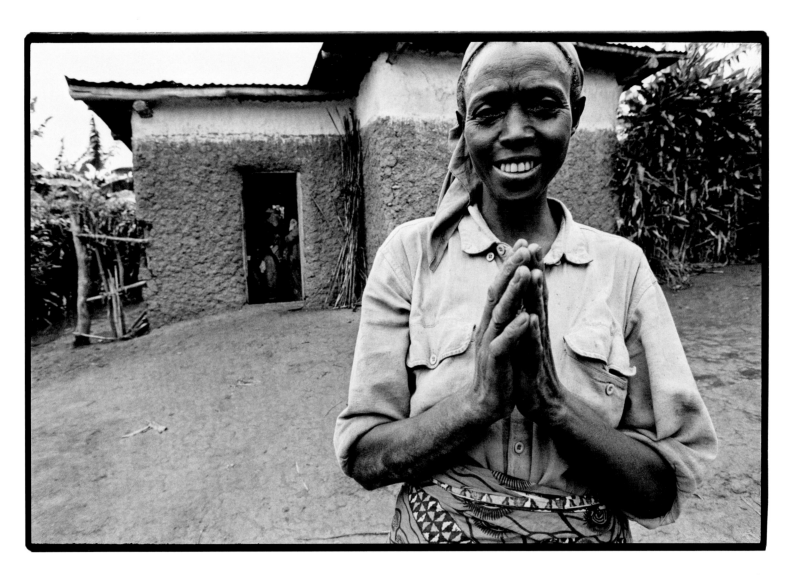

Having respect is having life.
Kenyan proverb

If you get peace, you get life.
Somali proverb

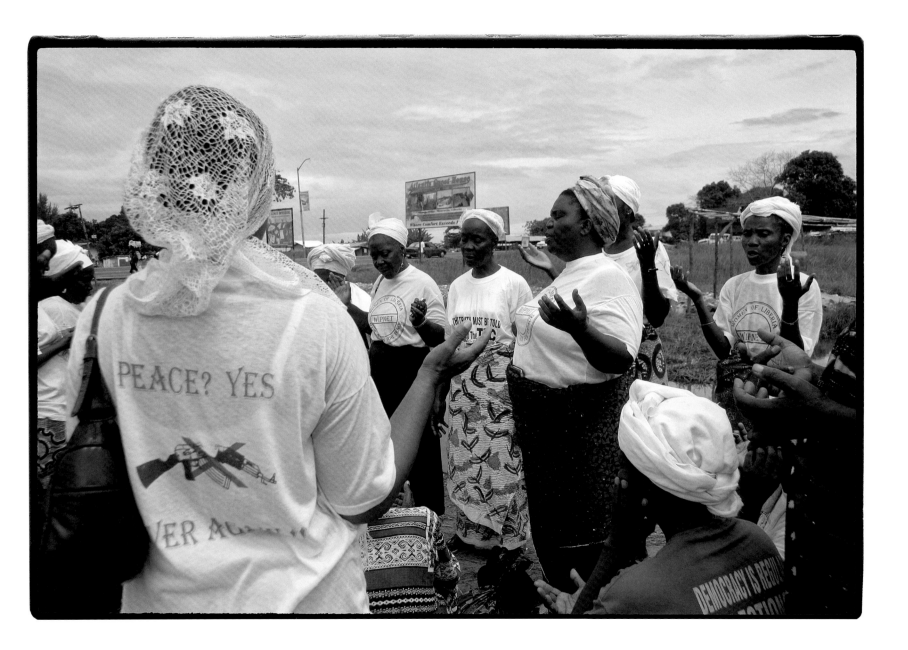

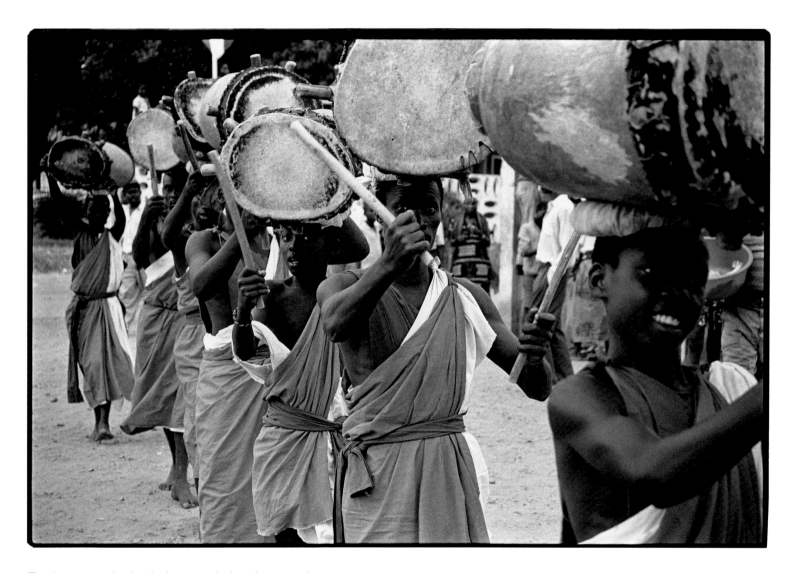

To dance is to be healed, reconciled and restored.
African proverb

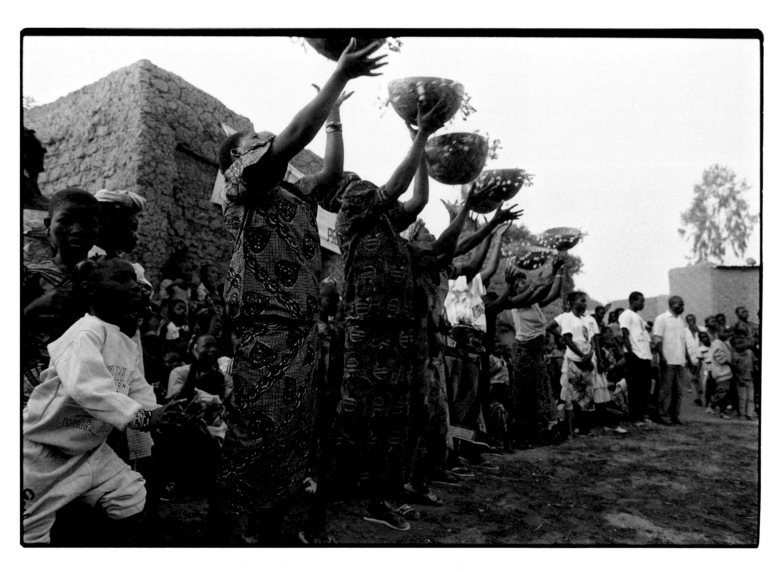

We dance, therefore we are.
African proverb

When the rhythm of the drumbeat
changes, the dancer must adapt.
Burkina Faso proverb

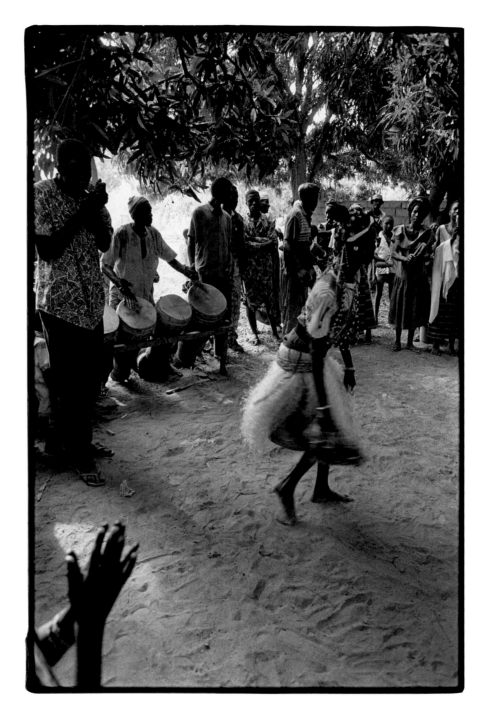

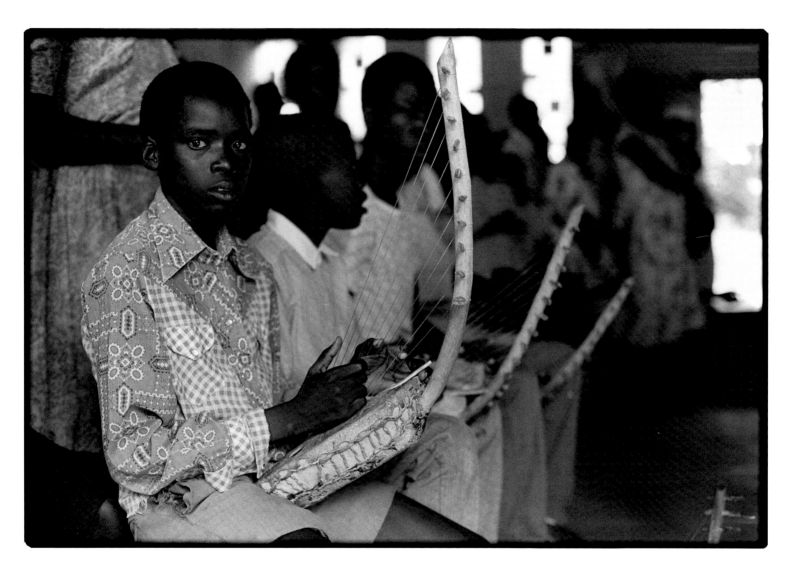

Tune your harp frequently.
Ugandan proverb

If you can talk, you can sing; if you can walk, you can dance.

Zimbabwean proverb

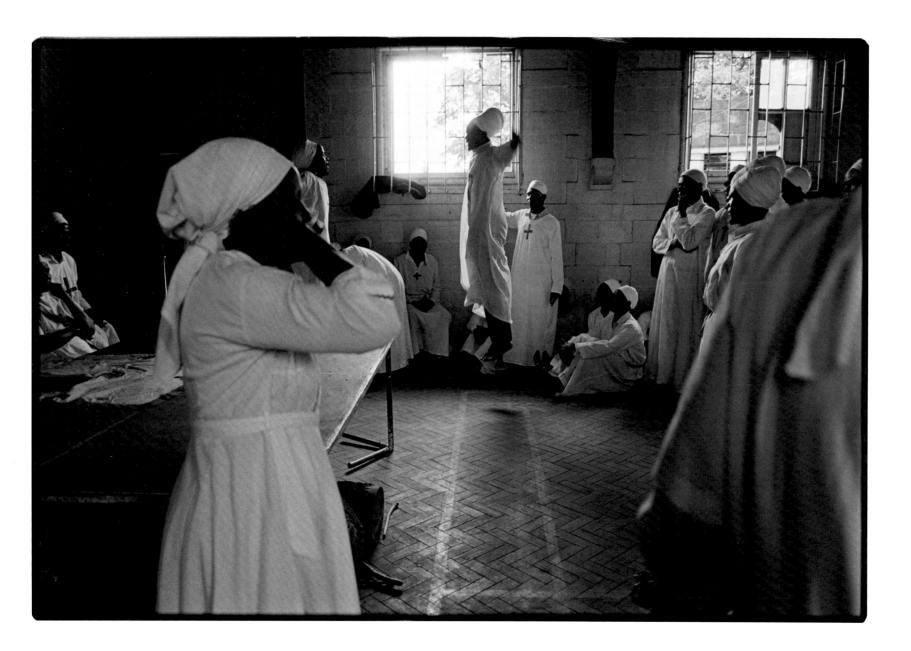

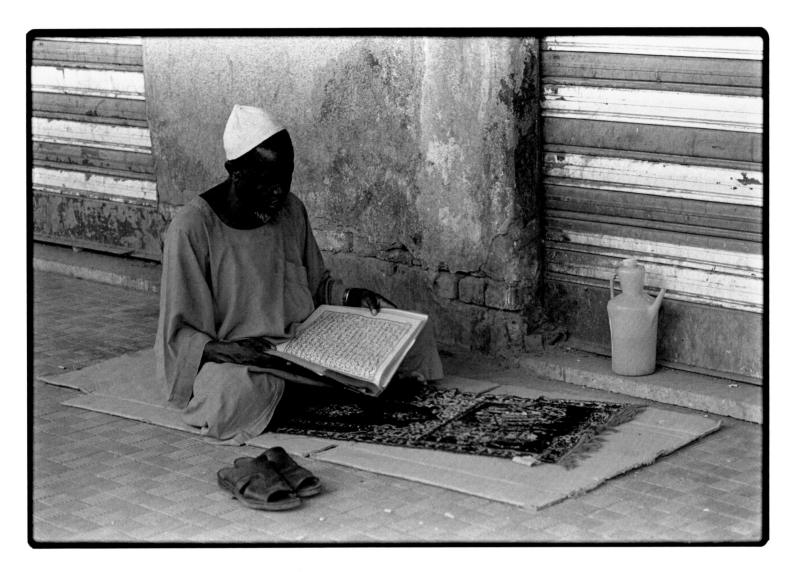

The spiritual is more important than the material.
Tanzanian proverb

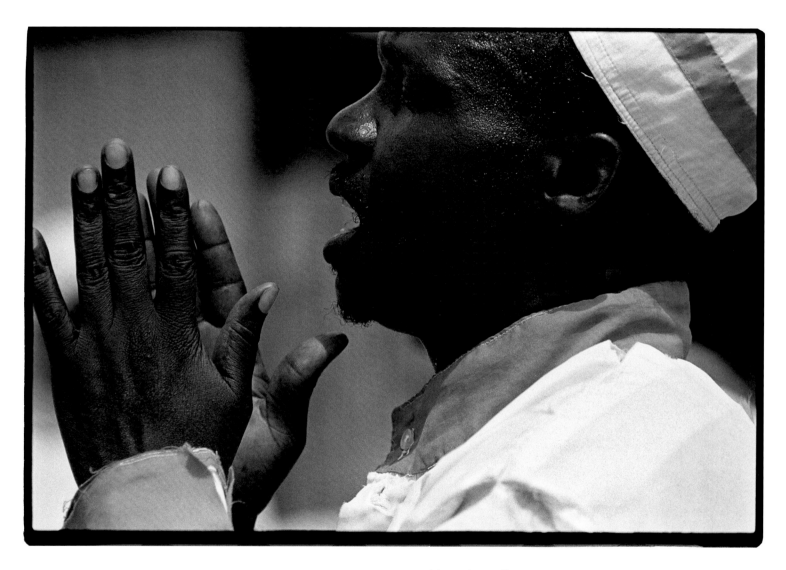

Ideas about God are like skins; each person adopts his own.
Ugandan proverb

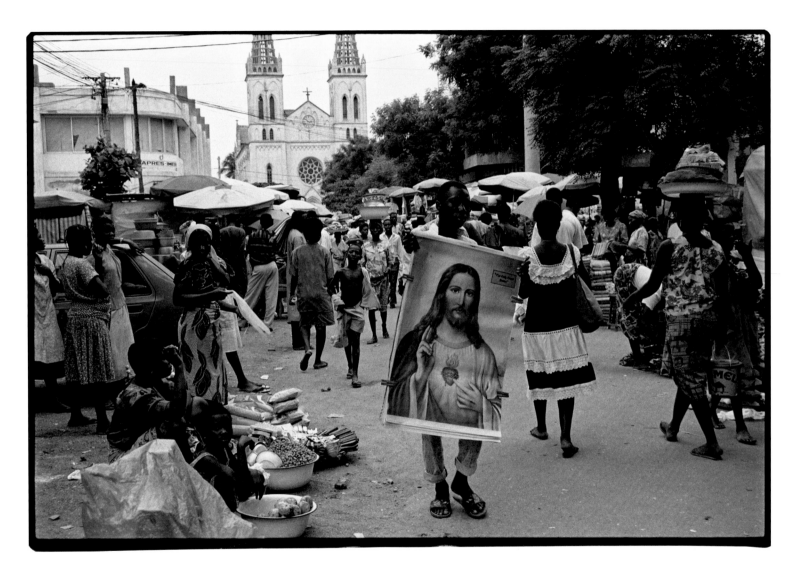

God is the contemporary of everything.
African proverb

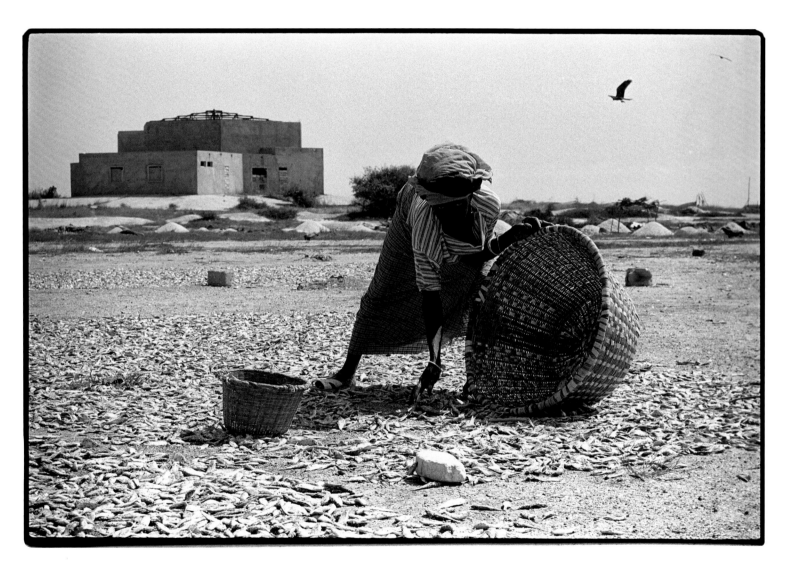

If you are going to ask from God, take a large basket.

Nigerian proverb

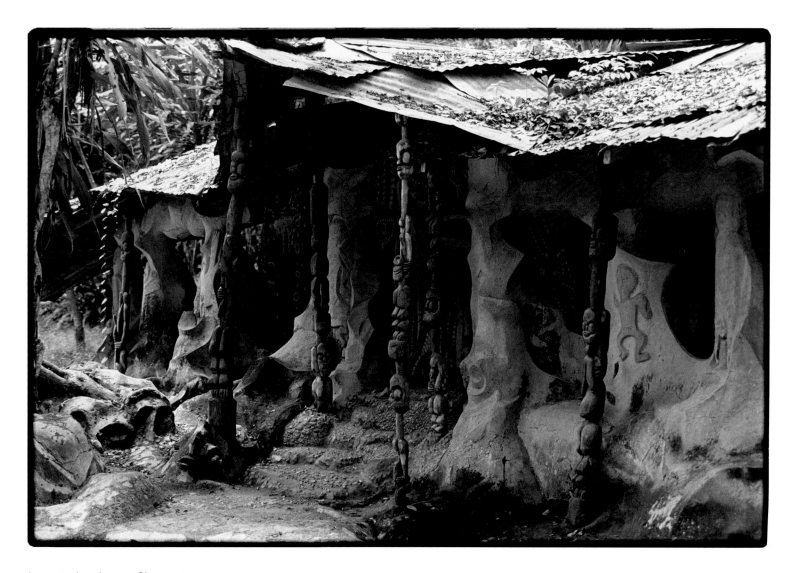

Love is the shrine of humanity.
Nigerian proverb

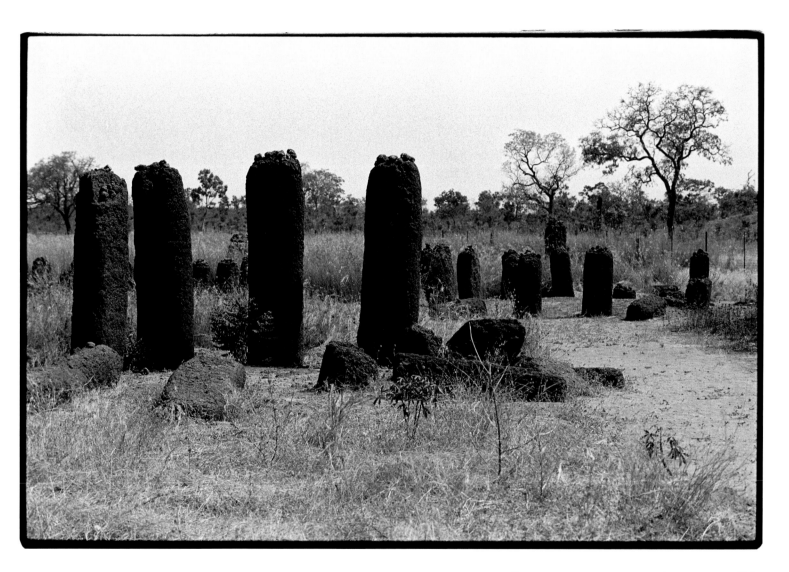

Our quest is to penetrate the mystery of life.
African proverb

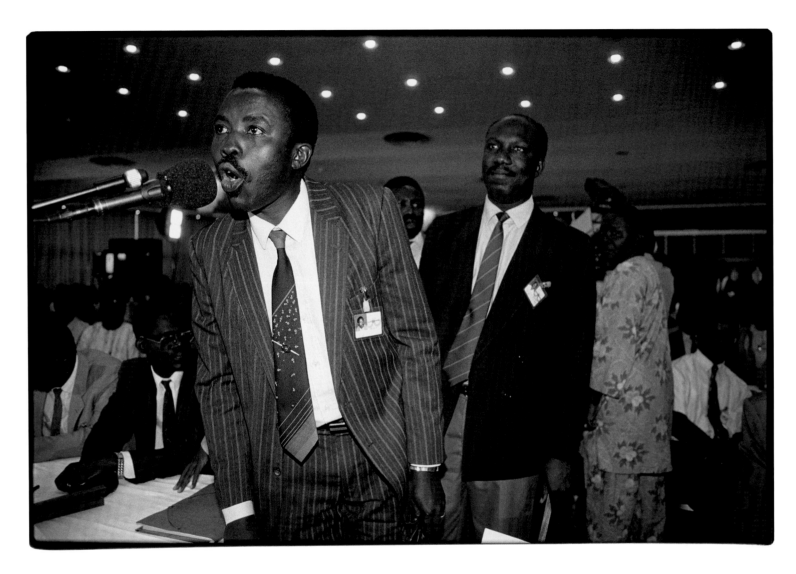

The word becomes time.
African proverb

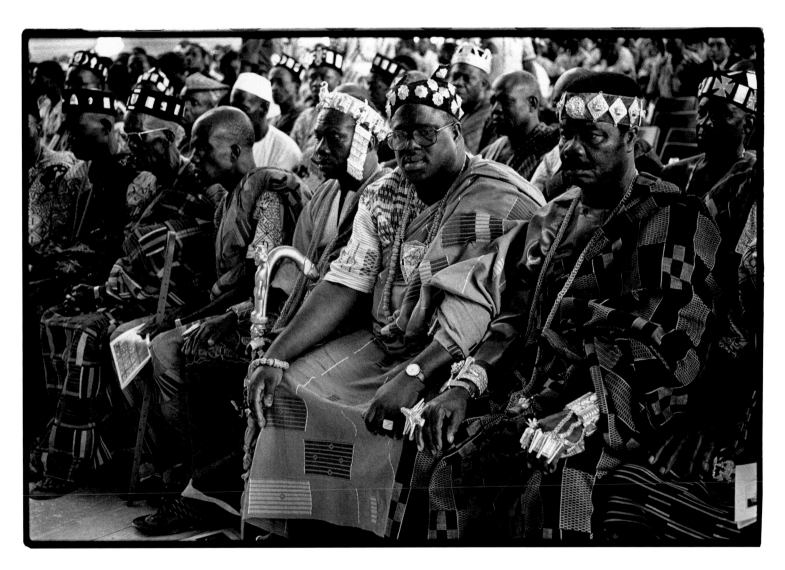

No one rules forever on the throne of time.
Ghanaian proverb

The wise do not comb themselves;
if they do, they get hurt.
Ugandan proverb

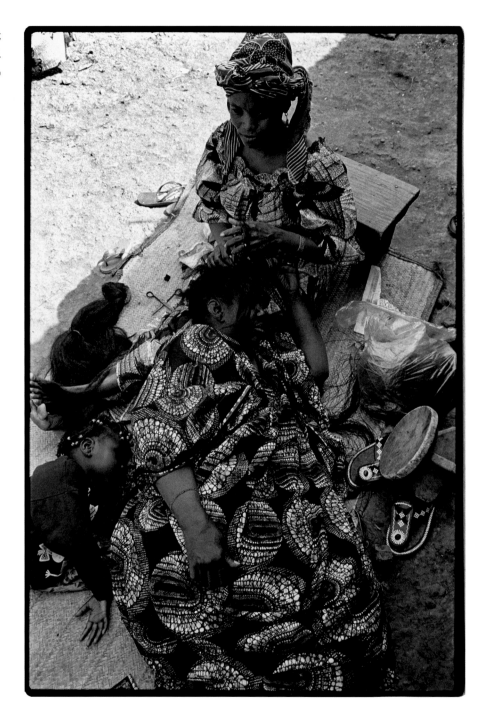

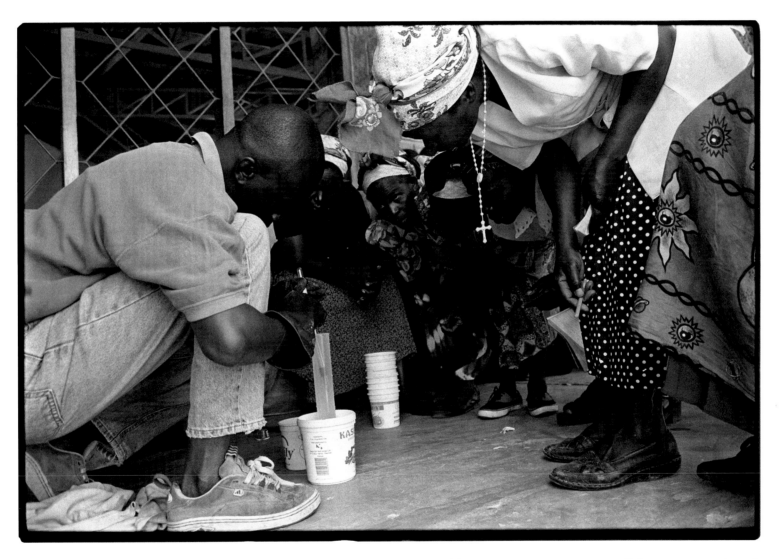

The wise person inquires into all things great and small.
Ethiopian proverb

Where there are two people, there is double wisdom.
Zambian proverb

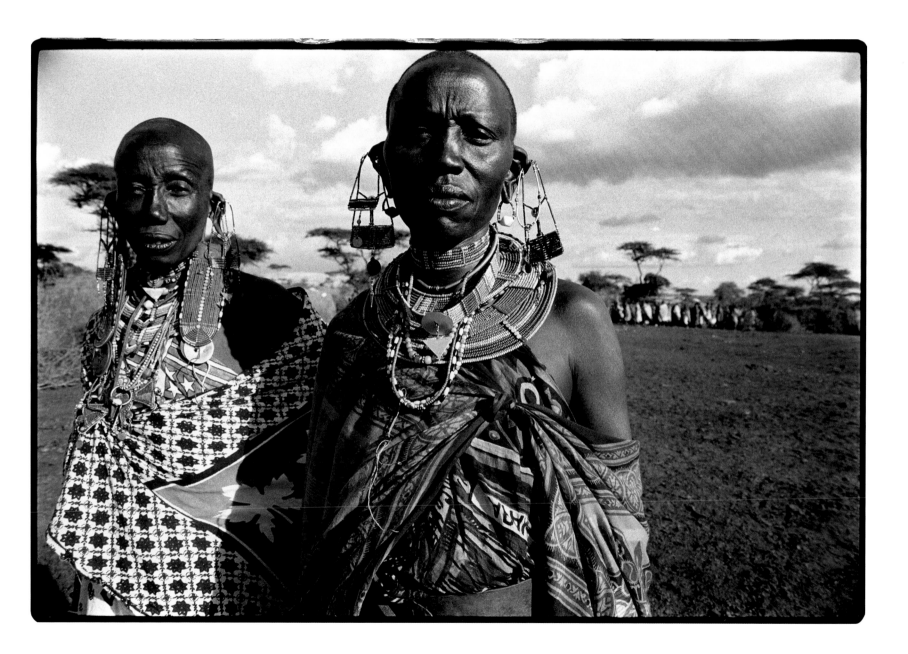

The heart of a wise man lies
quiet like clear water.
Cameroonian proverb

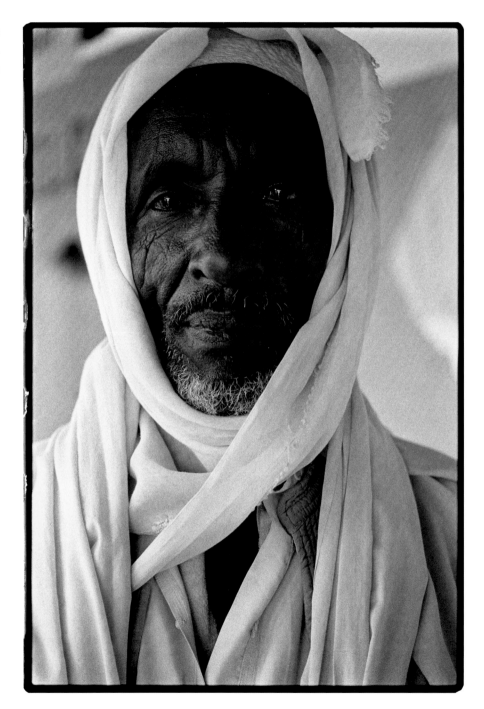

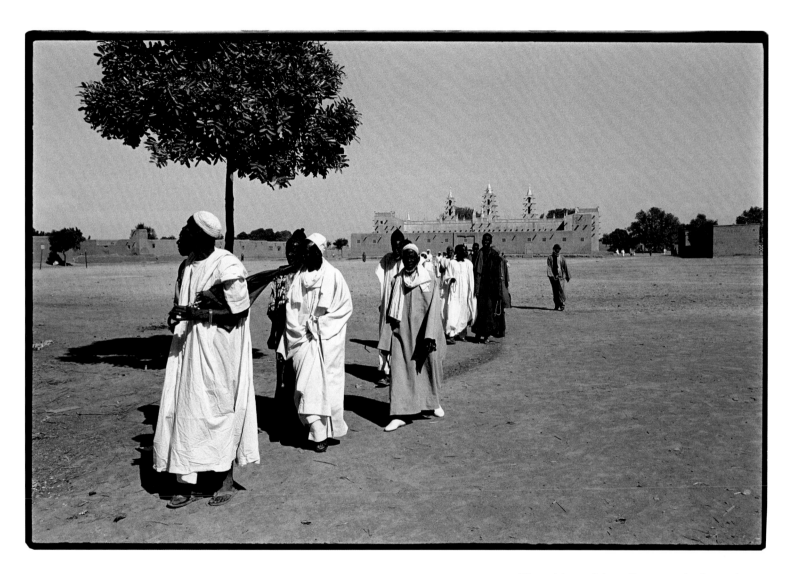

The elders of the village are the boundaries.

Ghanaian proverb

Old age is a history book for the youth to read.
African proverb

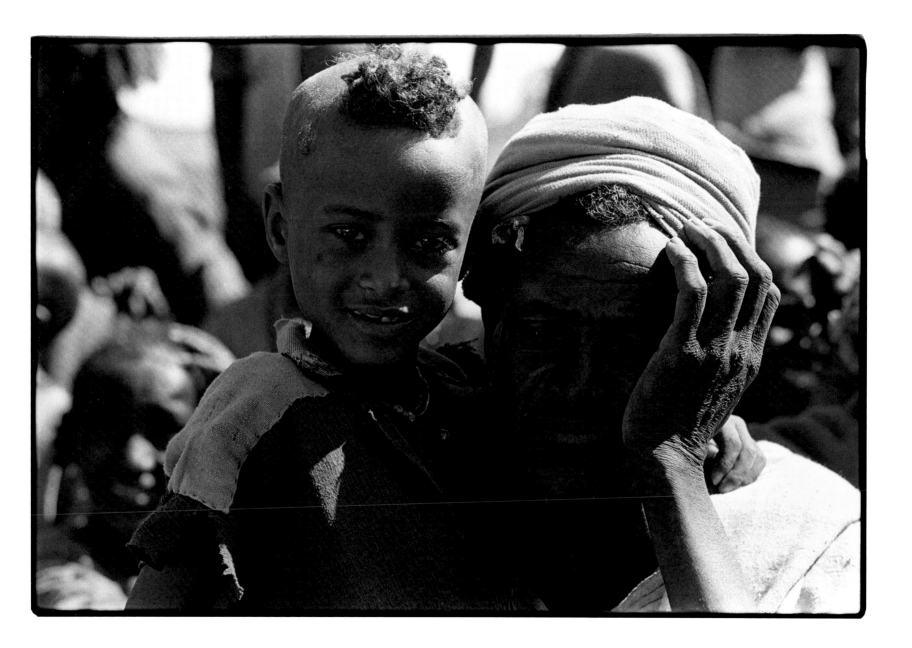

A long life is better than riches.
Kenyan proverb

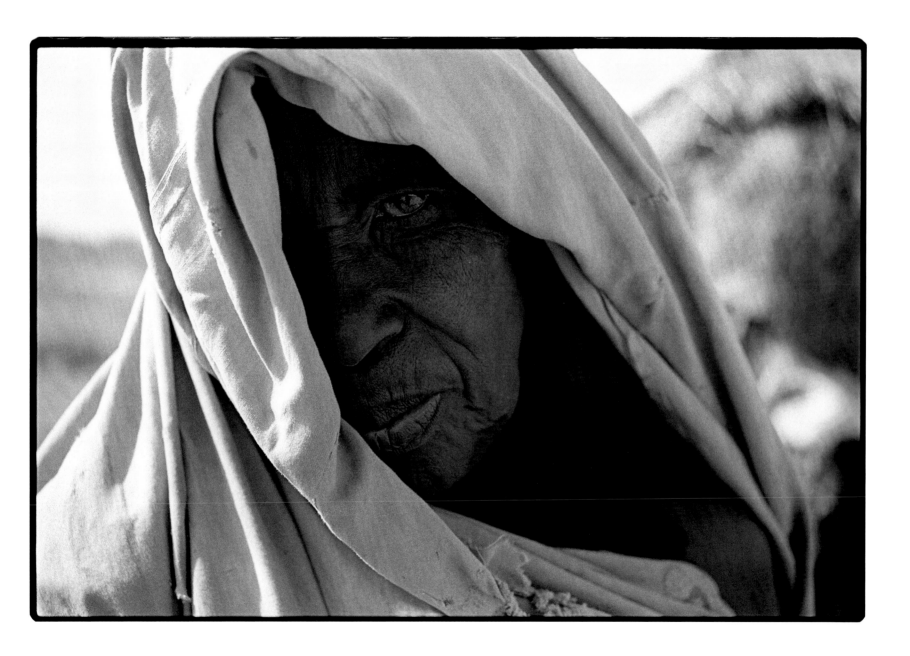

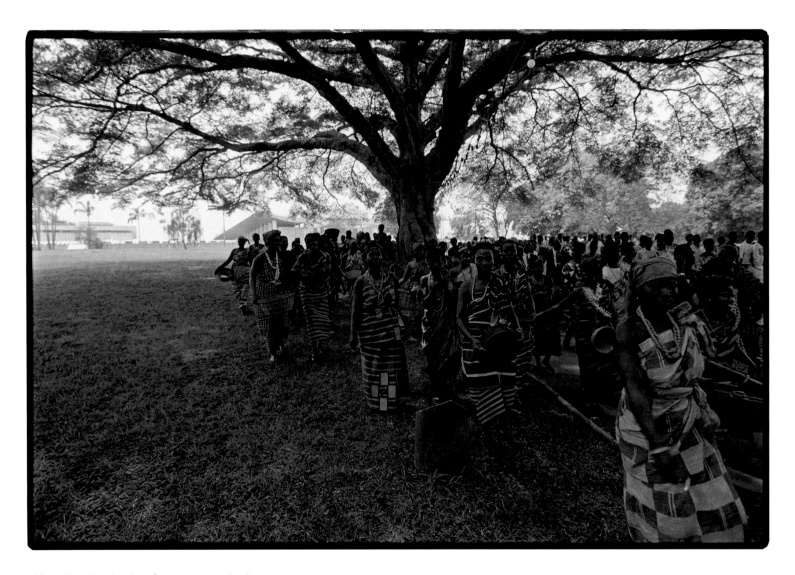

LIfe is like the shade of a tree; it easily disappears.
Nigerian proverb

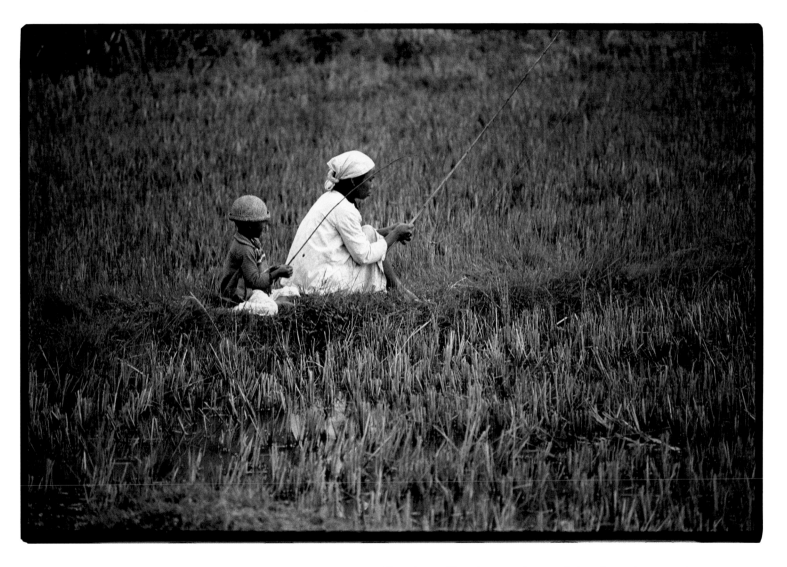

People are like plants in the wind; they bow down and rise up again.

African proverb

Life is like a vegetable that perishes
when the cultivator goes.
Ugandan proverb

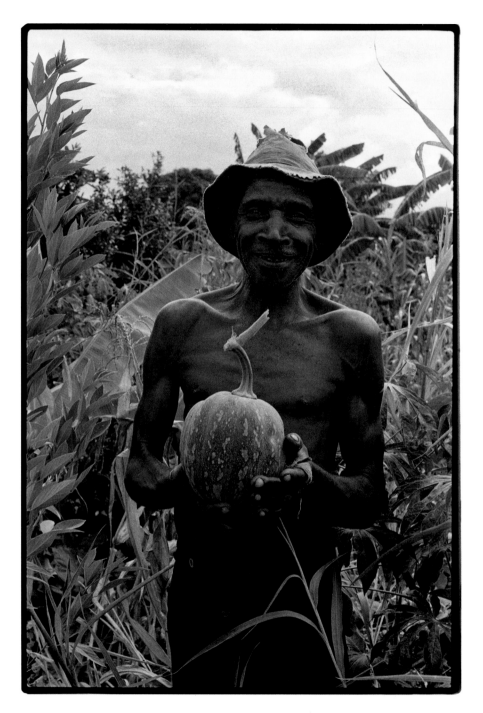

154

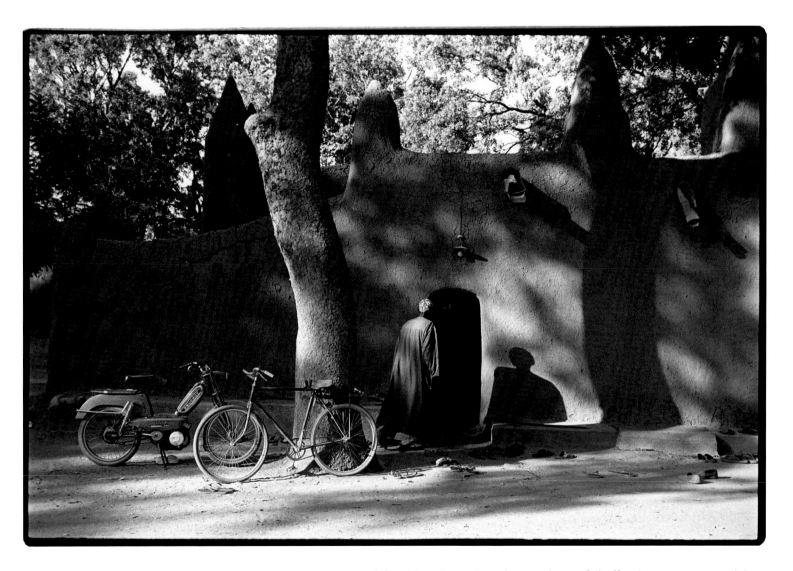

Life is like riding a bicycle; you do not fall off unless you stop pedaling.
Sierra Leonean proverb

Life is like shopping in a market; when you finish, you go home.
Ghanaian proverb

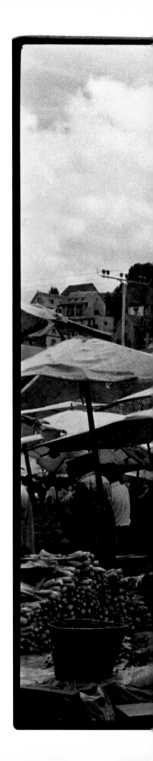

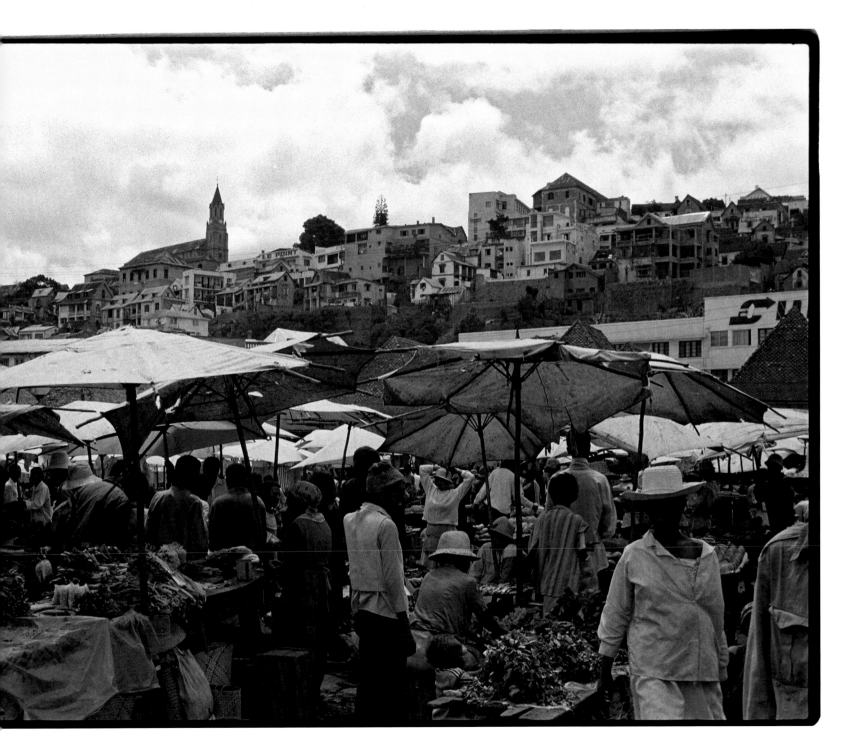

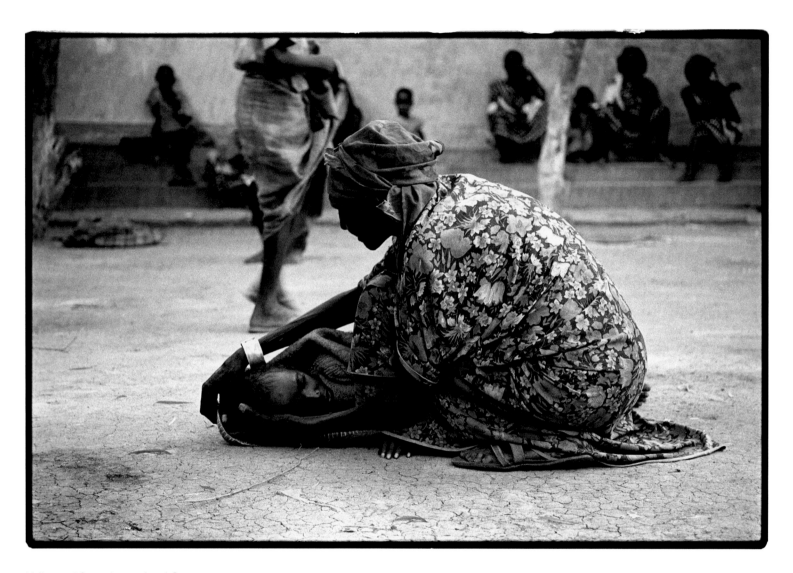

What is life without death?
African proverb

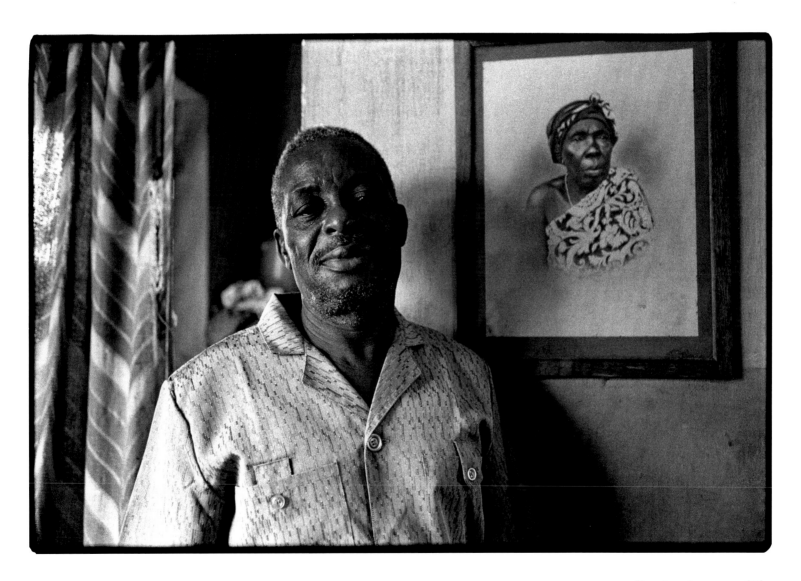

Death is the story of life.
African proverb

The pillar of the world is hope.
Nigerian proverb

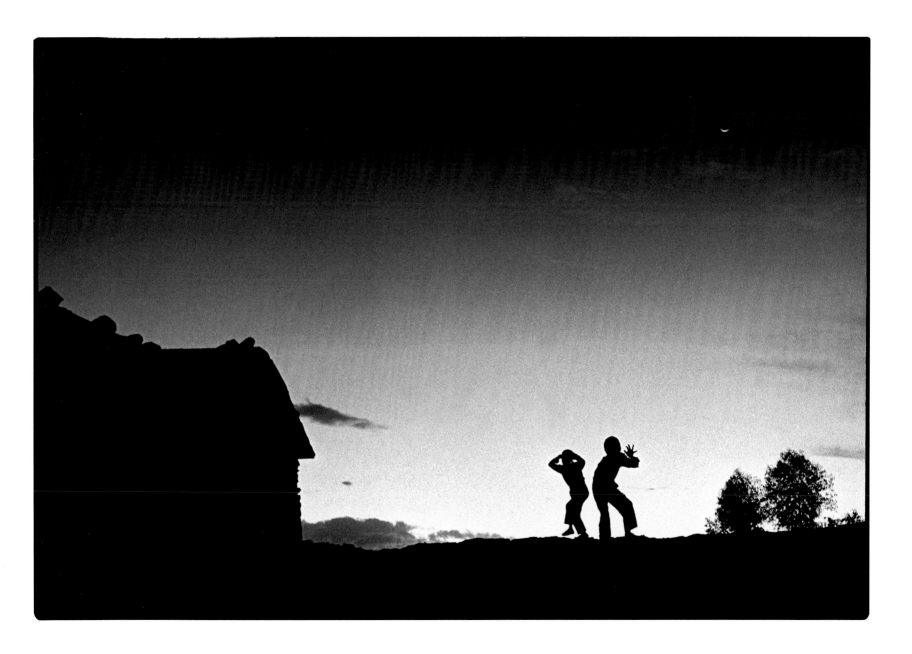

Dreams are tiny seeds from which beautiful tomorrows grow.
Sierra Leonean proverb

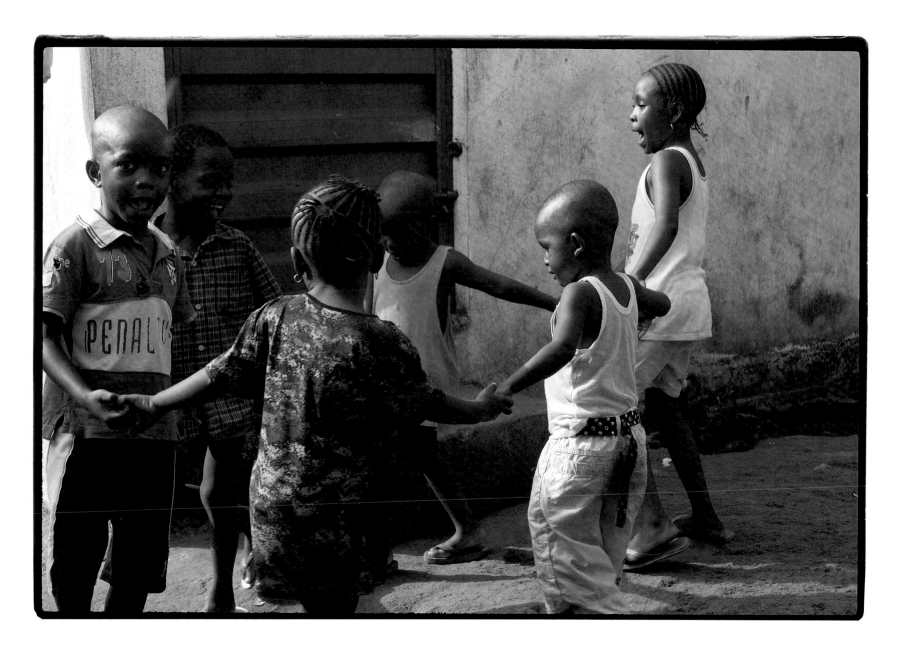

# Afterword

For many Americans, Africa exists in contradictory imaginings. In Africa we keep both the spare purity of Hemingway's Kilimanjaro and the sordid horror of Conrad's dark river. This huge and mysterious continent offers the glamour and romance of Isak Dinesen and the tragedy of our ancestors shipped away, weeping and in chains. Our visual knowledge of this unknown place is as clear, conflicting and untrue as our literary heritage. Africa is starving AIDS orphans and noble Maasai warriors, mass Tutsi graves and giraffes in full gallop on the sun-kissed veldt. It is a place limned for most of us by photojournalism and *National Geographic*. How, in the face of these dominating myths that make our Africas, does someone from America go there and learn anything, let alone take a picture that is true?

Betty Press first went to Africa in 1987. An accomplished photographer, associated with a major international newspaper *The Christian Science Monitor* for eight years, she made the pictures her job required, but found others, too, and it is these images that she has chosen to collect in this volume. Here we find a very personal Africa which does not contest the widely shared stereotypes so much as simply disregard them. Betty Press is a respectful and engaged observer who is drawn to simple subjects. In a remarkable melding of content and the medium of its expression, Press' images of Africa are timeless, immediate and personally authentic.

Photographers who produce within the demanding limitations of classic silver gelatin printing have a small vocabulary to work with compared to the options that the varieties of color work allow. For Press, it is a sure, albeit counterintuitive move to render the colorful cultures she observes in a cool monochrome abstraction that is the antithesis of the travelogue or the tourist brochure. Black and white relies on impeccable print quality, contrast and composition to capture a viewer's attention. Especially in black and white photographs, the critical element is often the quintessentially photographic one of the frame. In any photograph, these edges are what freeze a moment and separate one glance from the continuum of all the possible others. For Press, the frame simultaneously establishes meaning and defines an aesthetic. In one image, a mass of backs, shoulders, jewelry and costume pushes against the frame, manifesting abundance, vitality and joy. In another, the emphatic graphic of a native kanga wrap is reinforced by its repetition on two sets of shoulders and their movement across the frame. In another, a woman seated on the ground, nursing a baby and engrossed in a book, is centered precisely within the photographic rectangle, an icon for the facing proverb lauding education for women.

Annetta Miller has chosen African proverbs to accompany, expand and ground the pictures. They contribute an African voice to this American's vision. They demonstrate and exemplify the synthesis of cultures that these gentle pictures represent, and of a photographer who found her own Africa by letting Africa find her.

Alison Nordström
Curator of Photographs, George Eastman House, International Museum of Photography and Film

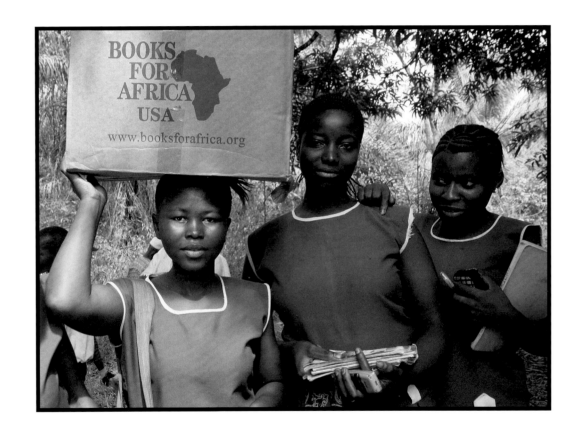

The mission of Books For Africa is to end the book famine in Africa. With everyone's help, we will help create a culture of literacy and provide the tools of empowerment to the next generation of parents, teachers, and leaders in Africa.

Books donated by publishers, schools, libraries, individuals, and organizations are sorted and packed by volunteers who carefully choose books that are age and subject appropriate. We send good books, enough books for a whole class to use.

They are shipped in sea containers from the United States to Africa. Since 1988, Books For Africa has shipped more than 24 million books to 45 African countries. They are on once-empty library shelves, in classrooms in rural schools, and in the hands of children who have never before held a book. Each book will be read over and over again. When the books arrive, they go to those who need them most: children who are hungry to read, hungry to learn, hungry to explore the world in ways that only books make possible.

# About the Authors and Contributors

For more than 20 years, Betty Press has photographed in East and West Africa, including eight years as an international photojournalist while she lived in Nairobi, Kenya. She has been widely published and exhibited. Currently, she is an adjunct professor of photography at the University of Southern Mississippi, in Hattiesburg and is married to Bob Press. Her photographs were featured in *The New Africa: Dispatches from a Changing Continent* by Robert M. Press/ Photographs by Betty Press, University Press of Florida. It received The Best of the Best from the University Presses - 2000 book award.

Annetta Miller, an American citizen, is a musician and a lover and collector of African proverbs. Born and raised in Tanzania, she has spent her entire working life in Tanzania, Sudan, and, since 1974, in Kenya, where she is currently retired. She is married to Harold Miller and they have two grown sons.

Proverbs in Africa are dynamic and are considered to be lodged and exercised in the public domain. These pithy sayings reflect and impart generationally-tested cultural wisdom and values. Proverbs in this book have been selected from Annetta Miller's personal collection of more than 100,000, derived from numerous oral and written sources during more than 60 years of living in Africa. She has produced six roto flip calendars featuring thematically-categorized proverbs, and is the author of *Sharing Boundaries: Learning the Wisdom of Africa*. Resources for further study are: African Proverb Series, University of South Africa, Unisa Press and African Proverbs Project at www.afriprov.org.

Joanne Veal Gabbin is the Executive Director of the Furious Flower Poetry Center, founder and organizer of the Wintergreen Women

Writers' Collective, and Professor of English at James Madison University in Harrisonburg, Virginia. A widely-published author, dedicated teacher and scholar, she has received numerous awards for excellence in teaching, scholarship and leadership. She is married to Dr. Alexander Gabbin and has one daughter, Jessea Nayo Gabbin.

Alison Nordström is Curator of Photographs at George Eastman House, Rochester, New York, the oldest and largest museum of photography in the United States. She was the Founding Director and Senior Curator of the Southeast Museum of Photography in Daytona Beach, Florida from 1991 to 2002. She has curated over 100 exhibitions of photography. At George Eastman House, she has initiated the contemporary biennial Vital Signs, and has curated Paris: Photographs by Eugene Atget and Christopher Rauschenberg, Why Look at Animals?, and Know War. She writes and lectures extensively on contemporary and historical photography.

Christiana Chinwe Okechukwu, Professor at Montgomery College in Rockville, Maryland is a widely-published author whose works include *Achebe the Orator: The Art of Persuasion in Chinua Achebe's Novels*. As an Ogidi woman from the same traditional Igbo village as Achebe, Okechukwu has special insights into the world portrayed in Achebe's novels. She is the executive director of Broadening the Horizon for at-risk youths: Inwelle Study and Resource Centre, Enugu, Nigeria www.inwelle.org.

# Index of Photographs

church in Kibera, Nairobi's largest slum. The bride kept her head covered and eyes lowered until she was pronounced married.

**38. Aba, Nigeria 1999** In this maternal hospital clinic, funded by Pathfinder International, mothers receive information about how to take care of themselves as they prepare to give birth.

**39. Kigali, Rwanda 1993** Maternal health clinics encourage mothers to bring their children for check-ups as a way to improve the health of mothers and children.

**40. Near Tamatave, Madagascar 1990** A mother looks fondly at her child.

**41. Nairobi, Kenya 1991** As part of the Baby Friendly program, mothers were encouraged to breastfeed. (Credit: UNICEF/ Betty Press)

**42. Nairobi, Kenya 1991** Home is where the family is, as this father, a taxi driver, knows. He stops to see his wife and child at his wife's vegetable stand. (Credit: UNICEF/ Betty Press)

**43. Jarso, Ethiopia 1990** A mother shyly agrees to be photographed with her child.

**44. Niger delta, Nigeria 1999** Children take a nap in the heat of the day.

**47. Isiolo, Kenya 1999** This Turkana mother started a small business selling kerosene as a part of a Trickle Up Kenya micro-finance project so she could send her daughter to school. She lives in a semi-arid area where houses are simple mud and thatch.

**49. Kibera, Nairobi, Kenya 1994**

These flower girls, who will carry the bride's train in the procession, are waiting for the wedding to start.

**50. Sokoto, Nigeria 1989** This Muslim girl attends a Koranic (religious) school where lessons are in Arabic. The board she carries serves as her writing pad.

**51. Southern Sudan 1993** I was on assignment to document famine in war-torn southern Sudan. It was a very difficult time for the people but the children always made the best of the situation. This young boy cleverly got my attention by imitating me, the photographer. (Credit: UNICEF/ Betty Press)

**53. Lomé, Togo 1992** On Sundays people flock to the beach to play and cool off. The normally quiet beach is filled with people of all ages but it is the children who seem to have the most fun.

**55. Southern Sudan 1989** A youth at an initiation ceremony. Such initiation ceremonies serve as rites of passage. In this case, it marks the passage from youth to manhood. Initiation rites vary from one ethnic group to the next.

**56. Lomé, Togo 1992** Early Sunday morning is the time to exercise on the beach, such as running or doing calisthenics. It is also a social day when friends come together not only to get in shape but also to have fun.

**57. Uganda, 2002** Volunteer peer educators and youth counselors were meeting to decide how to promote AIDS awareness in their local community.

**58. Cotonou, Benin 1991** The

streets of most African towns are lined with vendors doing business. Some of the more colorful ones are the barbershops. The young man who owned this shop let me take pictures of him cutting hair. Many of his street vendor friends stopped by to see what was going on. They agreed to pose for this portrait.

**61. The Gambia 1994** A Jola entertainer. For the Jola people of southern Senegal, entertaining and dancing are an integral part of their culture.

**62. Nairobi, Kenya 1990** Young dancers make up their faces in preparation for a dance. Many schools have extracurricular activities encouraging music, dance, and drama.

**63. Cotonou, Benin 1991** A. Jean Godjo Sonon, artist and sign painter, painted this advertisement to show hairstyles.

**64. Kisumu, Kenya 2002** George Opondo, a farmer, used a micro-finance loan from Trickle Up Kenya to expand his fruit and herb garden so that he could become self-sufficient in selling organic produce. He was also building his house using local materials and traditional African designs.

**65. Southern Sudan 1993** A Dinka woman is putting the final touches on her house, entirely covered with thatch, over an inner structure of wooden poles.

**66. Abidjan, Ivory Coast 1990** A woman hangs laundry in front of her home.

**67. Accra, Ghana 2009** A woman

crosses the street in downtown Accra. Even though stability and economic progress are evident in this city, many of its residents, drawn to the urban center, live in crowded conditions.

**69. Segou, Mali 1994** A boy leaves his traditionally built and designed adobe house, typical of this area.

**70. Masanga, Sierra Leone 2009** A classroom in a rural school built by Schools for Salone, a non-profit organization committed to helping Sierra Leoneans rebuild the many rural schools destroyed during their country's civil war.

**71. Enugu, Nigeria 1987** Education is highly prized, with parents working hard to pay for school fees and uniforms for their children.

**73. Freetown, Sierra Leone 2008** A nursery school pupil taking a break at Cardiff Preparatory School.

**74. Monrovia, Liberia 2006** Schoolgirl.

**75. Zanzibar 2002** Morning assembly at an Islamic secondary school.

**76. Hargeisa, Somaliland 1993** After the civil war destroyed many of the schools some teachers continued to teach in the partially demolished classrooms until they could be rebuilt.

**77. Southern Sudan 1993** A woman with her child on her lap takes advantage of an adult education class that was being offered in her community. (Credit: UNICEF/ Betty Press)

**78. Asmara, Eritrea 1993** An older woman signs her name before voting on independence.

**79. Bujumbura, Burundi 1993** Several youths watching an

educational video as a way of getting them involved in productive communal activities in a country burdened with ethnic violence.

**81. Tamatave, Madagascar 1990** Typical rural transportation.

**83. Lamu, Kenya 2005** As the sun sets, a dhow sails towards the Lamu waterfront. Many dhows like this one have proverbs painted on the prow.

**85. Massina, Mali 1994** Sunset over the Niger River.

**86. Narok, Kenya 1994** In East Africa many women wear kangas, colorful cotton wraps, with Swahili proverbs integrated into the design.

**87. Machakos, Kenya 1995** Women farmers greet each other as they get ready for the day's work. The women have formed a women's group in which they promote good farming practices involving terracing, small dams, and tree nurseries in this semi-arid area.

**88. Makeni, Sierra Leone 2009** Ladies staying in contact with friends after a meeting.

**89. Louga, Senegal 2006** In many African cultures, food is shared, those present partaking from a common dish.

**90. Asmara, Eritrea 1993** Drinking coffee together in small cafés is a way to keep in touch with friends and know what is happening in the community.

**91. Marrakech, Morocco 2007** Early morning at a café.

**92. Diafarabé, Mali. 1994** During the Peul Crossing of the Cattle Festival, the houses are cleaned, painted and decorated. This

courtyard was decorated with a cat's-paw pattern created by three fingers dipped in whitewash.

**93. Diafarabé, Mali. 1994** These elders were returning to their homes after celebrating one of the important festivals for the Peul people, the Crossing of the Cattle.

**94. Niger Delta, Nigeria 1999** A community-based health worker gives advice. This community based activity was sponsored by Pathfinder International at the grassroots level to foster cultural acceptance of family planning and deliver reproductive health care to some of the world's most vulnerable populations.

**95. Leer, Sudan 1994** A mother welcomes home her son who spent years in exile during the civil war. After years of separation, UNICEF arranged for children, like this boy, to be reunited with their families.

**96. Lagos, Nigeria 1999** In this modern kitchen the cook still uses the traditional mortar and pestle to make pounded yam.

**97. Accra, Ghana 1992** These women work in cooperatives to buy and dry fish to sell in the market. This is a cheap and very accessible food that most people can afford to eat.

**99. Ogoniland, Nigeria 1999** Women collect fish from the fishermen to sell in the market. In the oil-rich Niger delta, the Ogoni people have had their land polluted by the oil industry without benefiting from the wealth created by the oil boom.

**101. Monrovia, Liberia 2006**

A beauty parlor can be an easy small business for young women to start, as most women like to have their hair styled.

**102. Lamu, Kenya 2005** The bao game, which originated in Africa, is played throughout the continent.

**103. Niger delta, Nigeria 1999** A group of men play checkers on their porch overlooking an oil booster rig. Oil wells abound in this area; oil flares are common. The community lives with the oil industry in its midst but benefits very little from it.

**105. Lagos, Nigeria 1992** This man is lifting weights made from scrap metal.

**106. Mbao, Senegal 1988** While visiting a women's group that was setting up a dried fish business, I saw this woman sitting in a courtyard cleaning rice. As she was doing this most mundane job, she was beautifully dressed and so composed that even having her picture taken did not distract her from her work.

**107. Djenné, Mali 1994** During market day the plaza fills up with vendors' stalls and ambulant traders. It is the best day to visit Djenné because people from the surrounding villages pour into the city to buy and sell goods. They dress in their best clothes and catch up on all the gossip and events of the past week. Djenné has been an important commercial and Muslim center in West Africa for centuries.

**108. Haragwe, Ethiopia 1991** Women collecting water from an irrigation canal, funded by Lutheran World Relief, to water trees.

**109. Burkina Faso, 1988** Women

winnow millet after the harvest.

**111 . Djenné, Mali 1992** While visiting Djenné we took a tour of the countryside where the Bozo people live. We found these unusual, compact villages surrounded by mud walls, with a mosque towering over the homes. Inside, we walked the narrow streets visiting families in their mud-brick homes. After we left the village these children decided to go fishing in a nearby lake.

**113. Southern Ethiopia 1993** Harvesting teff, Ethiopia's preferred cereal crop. The grain is ground into flour, fermented and made into injera, a sourdough, flat bread. Teff straw from threshed grains is excellent animal fodder. It is also used to reinforce mud or plaster used in the construction of buildings.

**114. Maasai Mara, Kenya 2005** After the rains wildebeest, along with zebra, migrate annually in huge herds from the Serengeti in Tanzania to Maasai Mara National Reserve.

**116. Awash Valley, Ethiopia 1991** For the Afar people, who have huge herds of camels, camel milk is an important part of their diet.

**117. Ngora, Uganda 1990** Clay cooking pots for sale at the market.

**118. Awash Valley, Ethiopia 1991** Former militia member uses a feather to keep the barrel clean.

**119. Asmara, Eritrea 1993** This unfenced and unsecured military hardware dumping site was a popular playground for children who lived nearby.

**120. Goma, Democratic Republic of Congo 1994** During the genocide,

when families were on the move, many children were separated from their parents. They were placed in centers until they could be reunited with their families. (Credit: UNICEF/ Betty Press)

**121. Nassir, Sudan 1991**
This Sudanese refugee was carrying as many of her belongings as she could manage as she fled from the civil war.

**122. Mali, 1994** Community leaders discuss ways to strengthen the community.

**123. Rwanda, 1994** A grateful mother thanks the aid workers for their help in finding her children who had gotten lost during the genocide. (Credit: UNICEF/ Betty Press)

**125. Monrovia, Liberia 2006** The women's peace movement, which started during the civil war, was instrumental in helping bring peace to Liberia in 2003. They continued to meet even after the war ended.

**126. Nairobi, Kenya 2005**
Burundian refugees in Kenya keep alive their traditional drumming and dancing.

**127. Bamako, Mali 1992**
Dance is so important in all of Africa. At any festival, cultural event, or even political gathering there will be dancing as was the case here during the election campaign.

**128. The Gambia 1994**
A lone dancer displays her talent as a master drummer plays an array of four drums. The Jola people dance at every celebratory occasion.

**129. Ngora, Uganda 1990** Local musicians play their traditional

instruments at a church service.

**131. Northern Kenya 1990**
Maasai men dancing a traditional warrior dance.

**133. Nairobi, Kenya 1995**
Many Africans have started their own churches, which feature a blend of Christianity and traditional religion. This one was called the African Church of the Holy Spirit. During the service there was ecstatic dancing and talking in tongues. Members wear a uniform so people can easily identify them with their particular church.

**134. Khartoum, Sudan 1988**
Reading the Koran.

**135. Nairobi, Kenya 1995** Member of the New Jerusalem Church, an African Independent Church.

**136. Lomé, Togo 1992** A colorful, dynamic open-air market in downtown Lomé.

**137. Mbao, Senegal 1988** A woman dries fish on the beach to sell in the market. The women formed a cooperative to build a fish-processing center where they can dry fish in a more sanitary way and increase their production.

**138. Oshogbo, Nigeria 1992**
On the banks of the river there is a shrine dedicated to the Oshun fertility goddess. While the early Oshogbo residents were traveling, the goddess gave birth to the city's first king here. When the travelers returned, she asked only that they move farther uphill so her waters would not be disturbed. The area on the river was preserved as a shrine and later as a sacred forest.

Each year in August, thousands of people from many religions come to celebrate and worship at her shrine.

**139. Wassu, The Gambia 1994**
The stone circles of Senegal and The Gambia, dating from around 750 AD, are impressive and remain a mystery today. Stone circles of many types are found throughout Europe and the Near East, though nowhere is there so large a concentration as found on the northern bank of The Gambia river. It implies the presence once of a well-established, dynamic culture.

**140. Lomé, Togo 1991**
A speaker at the National Conference, which was held to promote democratic reforms in a country ruled by Étienne Eyadéma.

**141. Yamoussoukro, Ivory Coast 1994** President Houphouët-Boigny ruled Ivory Coast from the time of independence in the 1960s until a year before his death in 1994. His state funeral was attended by many heads of state as well as traditional chiefs. The latter came dressed in hand-woven gowns, gold jewelry, and other traditional accoutrements.

**142. Bamako, Mali 1992** A woman is having her hair styled. As it will take several hours, she makes herself comfortable, along with her daughter. Women in Mali have a sophisticated sense of fashion, particularly in terms of their clothes and hairstyles. The cheapest place to have their hair done is in the open-air market, where a large, covered shed is devoted to this trade.

**143. Embu, Kenya 2002**
The women are learning to make soap at an income-generating workshop funded by Trickle Up Kenya.

**145. Southern Kenya, 1995**
Two Maasai women at a blessing ceremony.

**146. Borama, Somaliland 1993**
Somali elder at a peace conference.

**147. Diafarabé, Mali 1994**
Elders leave the mosque after Friday prayers.

**149. Northern Ethiopia, 1987**
A father and son who survived the 1984-1985 famine in Ethiopia were threatened by another famine in 1987, but this time aid groups were ready to supply food to the affected areas.

**151. Northern Kenya 1993**
This elderly woman was a survivor of the civil war in Somalia and fled to a refugee camp.

**152. Abidjan, Ivory Coast 1994**
Women, carrying baskets, leave the government center where the body of the late President Houphouët-Boigny lay in state.

**153. Madagascar 1990** Mother and child fishing in the rice paddies.

**154. Morogoro, Tanzania 1991** Farmer proudly shows off his produce.

**155. Massina, Mali 1994**
Man parks his bicycle in front of the mosque as he enters for prayers.

**157. Antananarivo, Madagascar 1990** Downtown market.

**158. Baidoa, Somalia 1992**
After President Siad Barre was overthrown in 1991, civil war

erupted, causing a huge famine in Somalia. Many people, including children, died before humanitarian groups were able to get food to the affected areas.

**159. Lomé, Togo 1992**
A man poses next to a picture of his late grandmother.

**161. Asmara, Eritrea 1993**
This was a very hopeful day to be in Asmara because Eritrea had finally received their independence from Ethiopia after a long civil war. Most Eritreans were celebrating and dancing in the streets. As we toured the city at the end of the day, a group of children were dancing their way home after a soccer game. A new moon was rising in the sky and it looked like the boys were dancing on the edge of the earth.

**163. Baidoa, Somalia 1992**
In 1991, civil war caused a terrible famine in Somalia. When the rain began to fall, it brought huge smiles to the children living in an orphanage, who had survived the famine.
(Credit: UNICEF/ Betty Press)

**165. Freetown, Sierra Leone 2009** Children playing in a circle. Hopefully these children will never have to face the horrible events that their parents experienced during the vicious, decade-long civil war, which ended in 2002.

**Back Cover Kampala, Uganda 2002** A woman and child walk home after a visit to the health clinic.

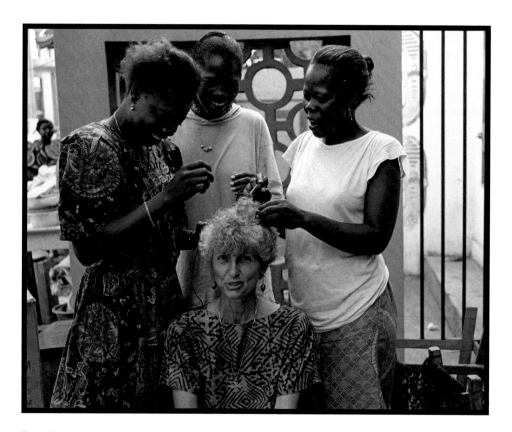

Betty Press, photographer, having her hair braided in an open-air beauty shop. Lomé, Togo

# Acknowledgments

In the spirit of the book, and realizing that it takes a community to publish a book, I would like to acknowledge:

First, the people all over East and West Africa who welcomed me and were willing to share their lives with the world through my photographs.

My husband, Bob. Together we traveled all over East and West Africa from 1987 to 1995 reporting on a changing continent, shared a Fulbright experience in Sierra Leone in 2008-09 and continue to visit when we can. He is my biggest supporter, friend and my love. Yvonne, our foster daughter, who helped me see Africa through her eyes; my family in the Midwest from where my journeys began.

Annetta Miller, and her husband Harold, who inspired me with their knowledge of proverbs and love for Africa; Donald and Ruth Thomas who befriended us and took us in on many of our later visits to Kenya; Patrick Plonski, Executive Director, Books For Africa; Joanne Veal Gabbin, Alison Nordström, and Christiana Chinwe Okechukwu for their contributions to the book; Joseph Opala, now living in Sierra Leone, for his support and encouragement; Paul Tynes, for his beautiful, elegant design, and his wife Raven, who appreciate Africa and will hopefully be able to visit it one day.

I came to photography in a non-traditional way. And for that I am grateful to the Knight-Wallace Journalism Fellows, University of Michigan, Ann Arbor, where, as a spouse of a Fellow, I was able to first study photography; The *Christian Science Monitor*, the first publication to use my photographs from Africa; fellow journalists and photographers for their help when I was a freelance photojournalist based in Nairobi, Kenya.

Some of the people who helped me along the way in the early years of my career: Hadija Ernst, who curated my first show in Kenya at Gallery Watatu, Nairobi; Eric Breitenbach and Gary Monroe, my mentors at then Daytona Beach Community College; Harry Messersmith, who as the director of the DeLand Museum of Art, DeLand, Florida, gave me my first solo USA show, "African Moments," which traveled to Principia College, Elsah, Illinois, and later with the help of guest curator and friend Harold Confer and wife June, to the Charles Sumner School in Washington, DC.

Faculty and staff colleagues at Stetson University in DeLand, Florida, especially Roberta Favis, Gary Bolding, Michael McFarland and Chris Nelson; and at the University of Southern Mississippi in Hattiesburg, John House, DeAnna Douglas, and Cathy Ventura; and my photography students over the years at USM and at Stetson, especially Pippa Stannard, who helped convince me to start teaching photography.

Friends and supporters in Kenya including Michael Chege, Damian and Elizabeth Cook, Ann McCreath, Chiuri Ngugi and his wife Ann, Pheroze and Villoo Nowrojee, Michael Ochoro, Susan Scull-Carvalho, John Sibi-Okumu, and Christine Wambui; in Sierra Leone, Gladys Conteh, Florence Kamara, Joseph Lamin, Abdul K. Lebbie, and Amy Challe; and in Liberia, Lyn Gray, Dickson Wotoe, and Hawa Konneh.

Other artists, photographers, and friends who are too many to mention, but especially Lynn Estomin, Laine Wyatt, Audrey Gottlieb, John Isaac, Cindy Brown, Anna Tomczak, Jennifer Coolidge, Sara Terry, Alexander Hau, Mary Virginia Swanson, Gary Chassman, Bunny McBride, Marcia Howe Umland, Diana Sommer, Carolyn Gaswick, David and Peggy Giltrow, Brian and Cricket Gordon, Skip LaRue, and the members of the art group who meet monthly in my studio. For artistic and technical support in Hattiesburg, Heidi Pitre, Tim Buckner at Frames & Panes, and Terry Lacy at Copy Cats Printing.

I would also like to acknowledge those who arranged
to exhibit my African work in the United States:
Larry Gawel at the WorkSpace Gallery, Lincoln, Nebraska;
Gary Colby at the Irene Carlson Gallery of Photography,
University of La Verne, La Verne, California;
Denise von Hermann, College of Arts and Letters,
University of Southern Mississippi, Hattiesburg;
Kerry Coppin at The New Gallery, University
of Miami, Miami, Florida;
Charles Parson at Rocky Mountain College of
Art and Design, Lakewood, Colorado;
Lynn Estomin at Lycoming College, Williamsport, Pennsylvania;
Katherine MacDiarmid, Art League, Daytona Beach, Florida;
Tom Jimison at the Baldwin Photographic Gallery,
Middle Tennessee State University, Murfreesboro;
Alison Nordström at the Southeast Museum of
Photography, Daytona Beach, Florida;
Michael Chege and Agnes Ngoma Leslie at the
University Gallery, University of Florida, Gainesville;
Peter Schreyer and Rick Lang at the Crealdé
School of Art Gallery, Winter Park, Florida.

Those who collected my photographs:
The National Museum of Women in
the Arts, Washington, D. C.;
Southeast Museum of Photography, Daytona Beach, Florida;
The Harry Ransom Center for the Humanities,
The University of Texas, Austin;
Jamestown Community College, Jamestown, New York;
Baldwin Photographic Gallery, Middle Tennessee
State University, Murfreesboro;
Public Art Commissions, Department of Transportation
and County Courthouse, Volusia County, Florida;
Stetson University, DeLand, Florida;
Maitland Art Center, Maitland, Florida;
Numerous private collectors.

Those who represent my work:
Panos Pictures, London, Adrian Evans, Director;
International Visions - The Gallery, Washington,
D.C., Tim Davis, Director;
One Off Contemporary Art Gallery, Nairobi,
Kenya, Carol Lees, Director;
Photographic Image Group, Portland,
Oregon, Guy Swanson, Director.

While I was working as a freelance photographer
I was fortunate to work with some organizations
that are doing great work in Africa:
UNICEF, Ellen Tolmie, Senior Photography Editor,
arranged many of my photographic assignments
including the ones to photograph UNICEF Goodwill
Ambassadors Audrey Hepburn on her trip to Somalia
in 1992 and Harry Belafonte to Rwanda in 1994;
UNHCR, photo editors Anneliese Hollmann and Suzie Hopper;
Schools for Salone (Sierra Leone), Seattle,
Washington,  Cindy Nofziger, Executive Director;
Trickle Up, New York;
Pathfinder International, Watertown, Massachusetts;
Catholic Relief Services, Baltimore, Maryland;
Maryknoll Magazine, Maryknoll, New York;
Episcopal Relief and Development Fund, New York;
Lutheran World Relief, Baltimore, Maryland.